Drawing Human Portraits

Step by Step Guide

How to Draw Human Portraits

from Scratch

By Eve Maiden

Copyright©2016 Eve Maiden

All Rights Reserved

Copyright © 2016 by Eve Maiden

All rights reserved. No part of this publication may be reproduced, distributed, or transmitted in any form or by any means, including photocopying, recording, or other electronic or mechanical methods, without the prior written permission of the author, except in the case of brief quotations embodied in critical reviews and certain other noncommercial uses permitted by copyright law.

Table of Contents

Introduction	5
Chapter 1: Creating Facial Balance through Spacing	8
Chapter 2: Practicing Proper Spacing & Size	17
Chapter 3: Creating Expressive Eyes	24
Chapter 4: Natural Looking Pupils, Lids, and Brows	29
Chapter 5: Detailing the Iris, Pupil, Lips, and Ears	37
Chapter 6: Contouring the Face	42
Chapter 7: Creating Expression & Strength	46
Chapter 8: Over the Shoulder Pose	61
Chapter 9: The Slightly Tilted Head	77
Chapter 10: Creating the Tilt and Downward Face	90
Chapter 11: The Youthful Portrait	97
Chapter 12: You're on Your Own	103
Conclusion	115

Disclaimer

While all attempts have been made to verify the information provided in this book, the author does assume any responsibility for errors, omissions, or contrary interpretations of the subject matter contained within. The information provided in this book is for educational and entertainment purposes only. The reader is responsible for his or her own actions and the author does not accept any responsibilities for any liabilities or damages, real or perceived, resulting from the use of this information.

The trademarks that are used are without any consent, and the publication of the trademark is without permission or backing by the trademark owner. All trademarks and brands within this book are for clarifying purposes only and are the owned by the owners themselves, not affiliated with this document.

Introduction

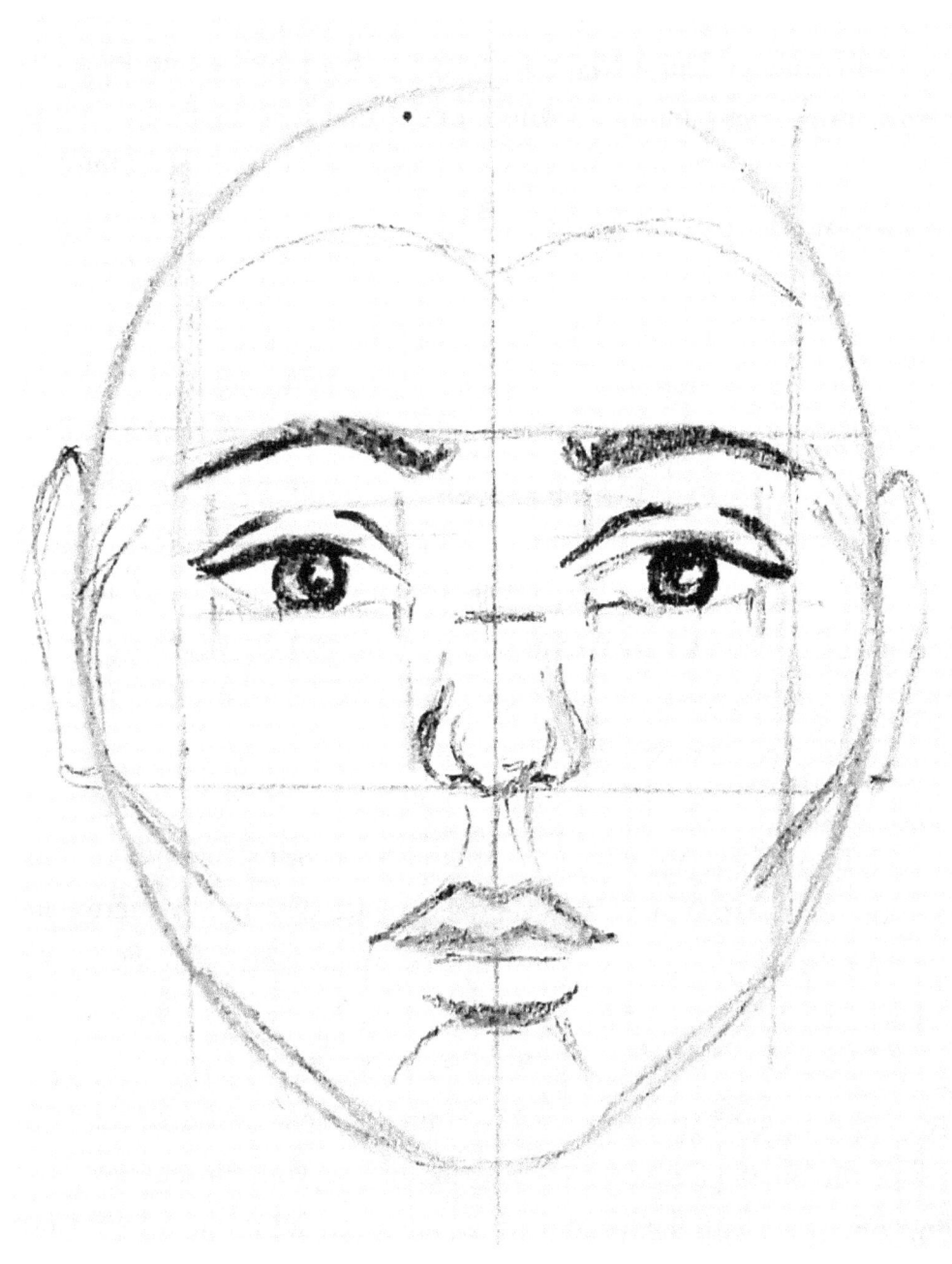

Drawing the human face doesn't have to be such a challenge when you learn a few basic rules about balance and expression. Before you begin your sketch, take inventory of your own face. You'll notice a few truths. Every face is different and definitely not perfect. Sometimes one eyebrow is thinner or lower than another. Often, one eyelid is droopier or elongated more than another. For our purposes in these step-by-step sketches, you will learn how to give the human face a realistic expression and overall balance.

Once you have mastered the basics, then you can experiment by exaggerating angles, spacing, and shading to give your portraits their own unique character. As we go, keep in mind that what make the difference is spacing and shading, working with rounded or angular lines, and creating realistic lightness and shadows that will bring your portrait to life. Typically, softer, rounder strokes and more light will display more feminine qualities to the face—while sharper angles, heavier strokes, and more shading will develop a more masculine look.

With each illustration, we will provide step-by-step instructions on how to achieve the look, expression, and gender you are desiring by manipulating shadow and light, spacing between features, angles versus curves, and that all important balance.

Don't be discouraged if your first few attempts look awkward; that's to be expected. It takes patience and practice before you can achieve a well-proportioned face with balanced features and authentic expression. Notice I didn't say, practice makes perfect! The last thing you want is the perfect face—people are not perfect. Attempting to make your drawing perfect will only result in frustration and unrealistic results.

Instead of perfection, go for balance, acceptable reality, a look that almost seems to speak without movement or sound. For example, a calm expression should draw the observer into the eyes. A sensual look should direct the gaze to fuller, poutier lips and perhaps heavier lidded, elongated eyes. If you are sketching a male face, notice the sharper angles of the face, and the stronger, heavier line of the brow.

The difference in features is created through shading, by contrasting light and dark. Mastering the basic steps of drawing human portraits will give you an excellent foundation from which to deviate. The mistake many beginners make is that they never learn the basics. Therefore, their human portraits look asymmetrical—almost as if you could fold the sketch in half and see two different faces.

It's a great advantage to have the step-by-step guidelines when drawing human portraits. By breaking down the drawing into blocks of progression, and then those blocks further divided into steps, you'll always be able to create the proper balance. Experimenting with shadow, light, and space in your portraits will encourage an emotional response from the observer. The more you practice these steps, the more appealing your portraits will become. Be patient with yourself. Every beginning artist has a learning curve, so learn to enjoy the process, and you will better appreciate your finished work.

Chapter 1: Creating Facial Balance through Spacing

The human face comes in all shapes and sizes, so use these steps as a guideline to create a natural balance and calm expression. Before creating a human portrait, it's important to know the purpose of the portrait. In other words, what do you want this person's face to convey? Do you want the face to show strength, gentleness, love, anger, or fright? Knowing this beforehand will enable you to create the expression you desire and the emotion you wish to convey.

Step #1: Overall Face Shape

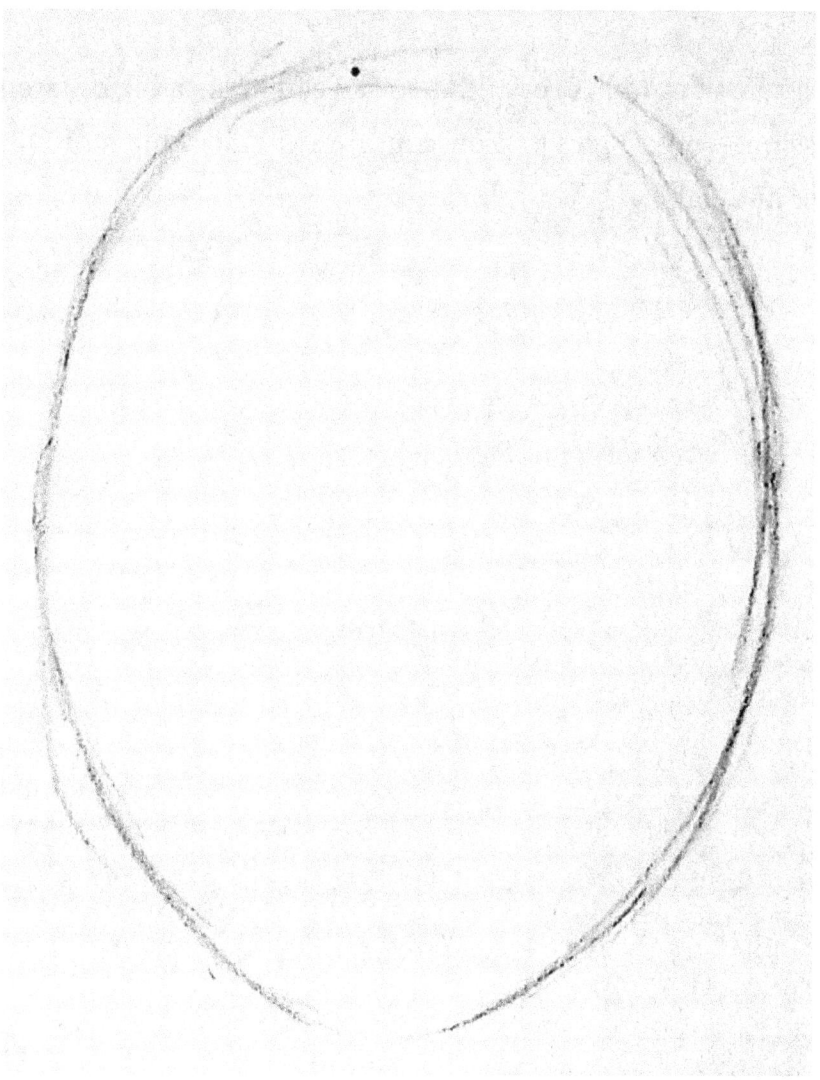

- Begin by drawing an oval, much like the shape of an egg.

- For a softer, more feminine look, keep your lines lighter and make your oval a little rounder in its center.

- For a more masculine appeal, use a heavier stroke. Around the bottom third of your oval sketch in some more sharp lines where the jawline would be.

- A good rule of thumb, every little stroke can make a big difference in the expression—so go lightly. You can always add a bit more shading or heavier lines later.

Step #2: Finding Your Center

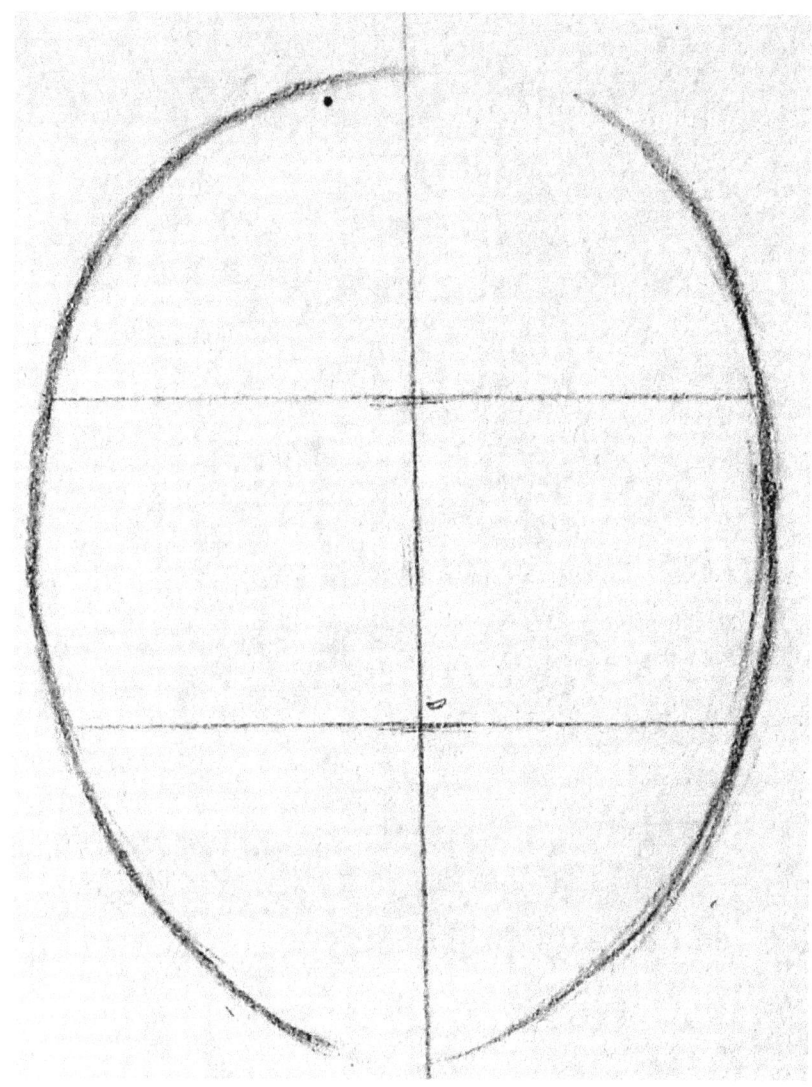

- Draw a light line down the middle of your oval. Keep your strokes relatively light at this point so as not to interfere with the details you will be adding as we go along.

- Extend both the top and bottom of the line outside the oval. Contrary to what you learned when coloring as a child, it's not necessary to stay within the lines.

Step #3: Creating Balance

- Now you're going to divide your oval, or face, into thirds.

- Look in the mirror at your own face.

- Notice that the human face can be easily sectioned into thirds.

- The top third contains the hairline and the forehead.

- The middle third consist of the eyebrows, the eyes, the nose, the cheeks, and the ears.

- The bottom third of the face holds the mouth, the jawline, and the chin.

Step #4: Spacing the Features

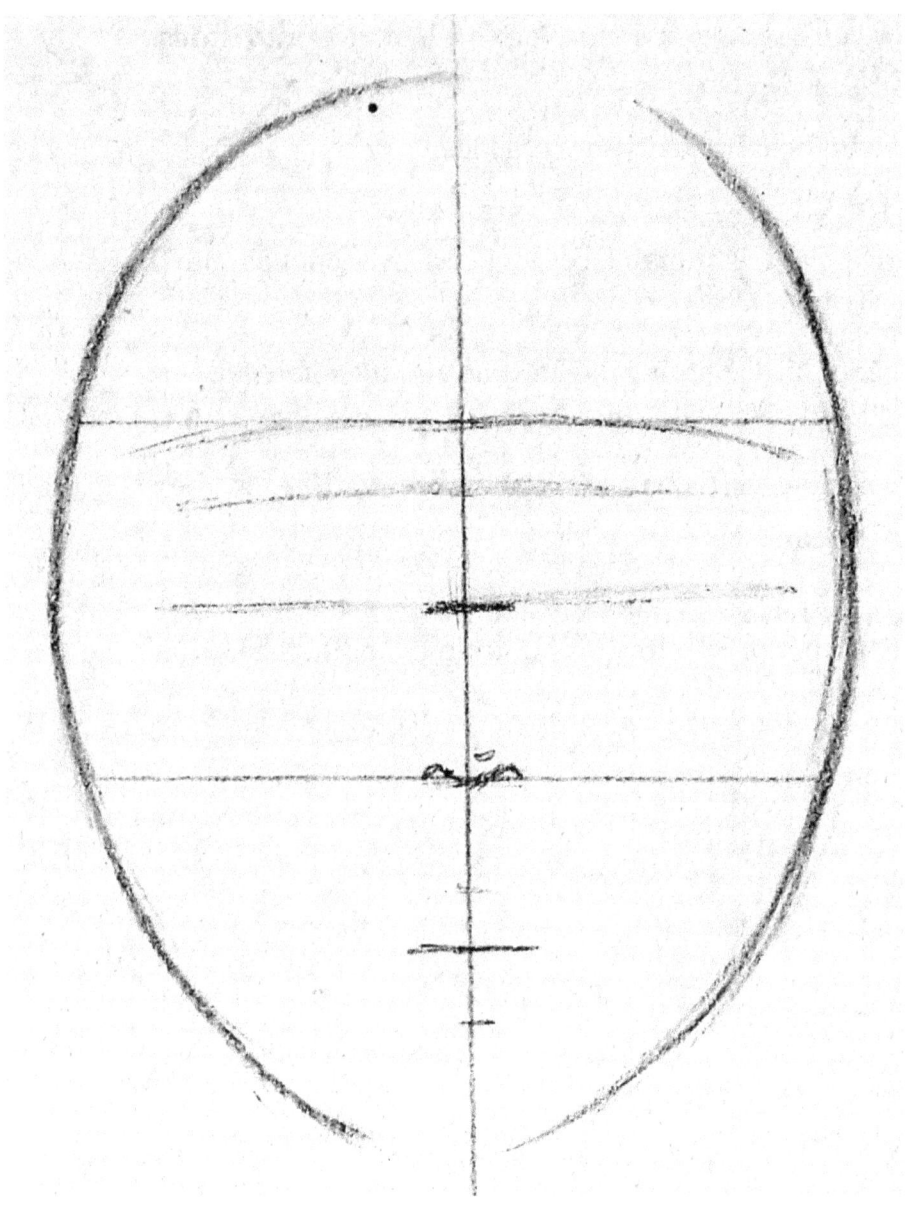

- Let's begin in the middle section of our oval, or face.

- To create the nose, draw a small, darker horizontal line at the bottom of your center section. This line should be where your center line intersects with the lower part of your middle section.

- To make it appear more like a nose, you may want to give it a little wave. Remember how you used to draw birds in the sky as a kid—with the center pointing downward and a little lift to its wings. This is how to make the nose look at first—like a tiny little bird.

- Now, at the center point in the middle section, just above the nose, draw another darker line. Make it about the same width as the tip of the nose. This will later become the bridge of the nose.

- Extend the line out toward the cheek line, but don't cross the outside of the face. Leave some white space on the side, so you can use the line for measuring when you begin to fill in the features.

- Still working in the middle section, about midway between the top horizontal line and the center point, draw another line through the face. Make it about the same length as the line used for the bridge of the nose.

- At the top line of the middle section, begin to give your face a little softness by curving the line. This will later become your eyebrow placement.

- Lastly, draw a line between the bridge of the nose and the eyebrow line. This will determine the width of the eyes and spacing between the eye and the brow bone.

Step #5: The Final Touches for Feature Placement

- Moving to the bottom third of the face, place a line about midway. It should be at the center point, even with the nose. This will be the lip line

- Now draw a line half way between the lip line and the top line of that section. This will later become the top of the lip.

- Using the same technique, draw a line about halfway between the lip line and the bottom of your face. This will become the bottom lip.

- Back off from your face to get the bigger picture. You should begin to see the balance of features you will add in the next few illustrations.

Chapter 2: Practicing Proper Spacing & Size

Since the eyes are said to be the window of the soul, that's where we will focus first. The eyes in your portrait will be what create most of the facial expression. It's the eyes that also solicit the emotions of those looking at your portrait, so be patient with these basics. Paying attention to achieving the initial balance in your portrait will reward you down the road with a portrait that is well-proportioned and appropriately expressed.

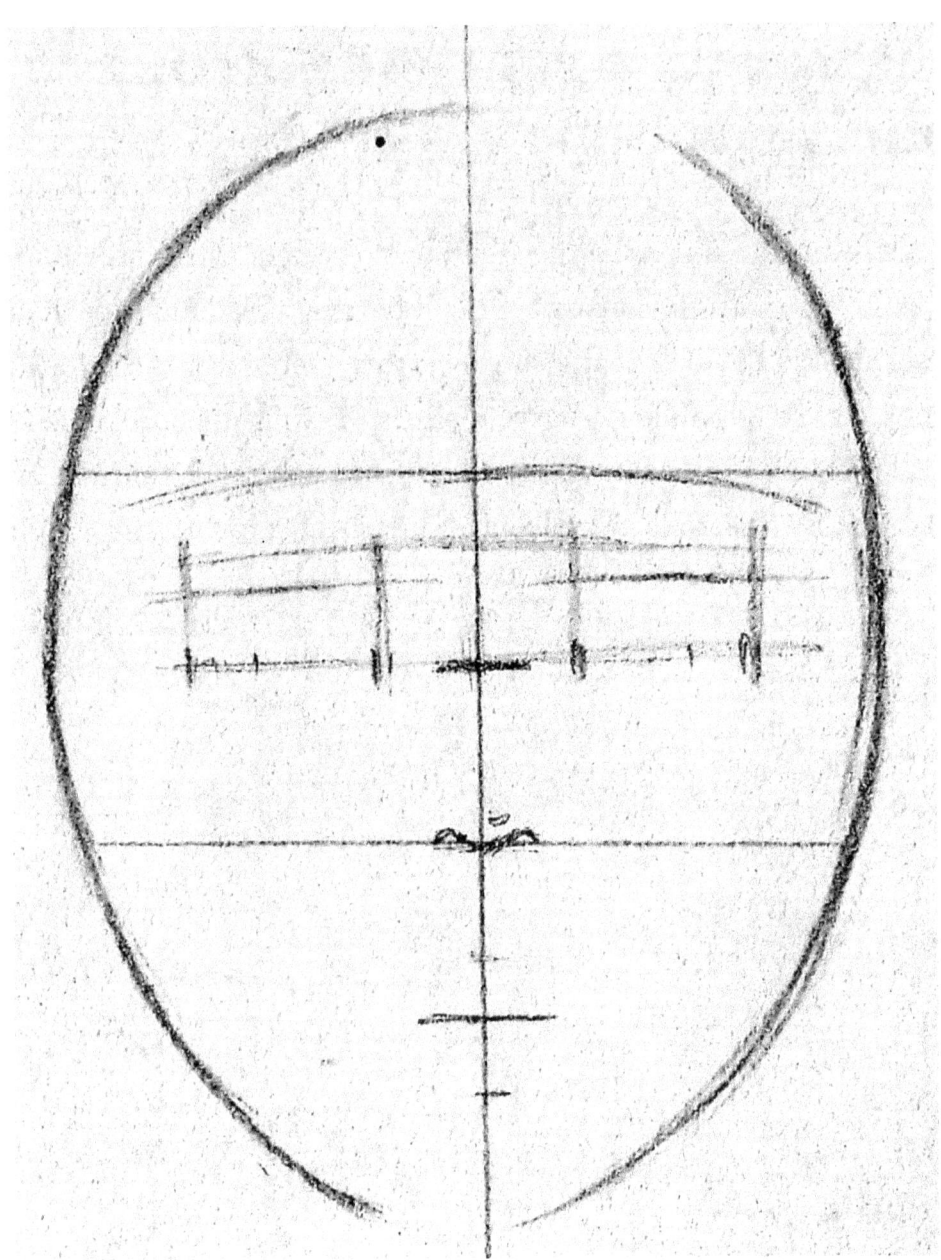

Step #1: Spacing the Eyes

- At the bridge of the nose center point to the line right above, this section is where the eyes will be formed.

- Looking at the illustration, you'll notice that it resembles three boxes.

- Each box should be equal in size.

- The middle box should be centered over the line that will define the bridge of the nose.

- The eye boxes should be of equal size.

Step #2: Temple Spacing

- When you have completed your three boxes, erase the lines that extend out to the temple of your face. This will prevent confusion as you continue to detail your portrait.

- Notice how you have clearly defined where the eyes will be located with the bridge of the nose.

- Don't be concerned if the bridge of the nose appears to be a little wide. It will all come together as you fill in the details later.

- Now look at the temple spacing on each side the eye boxes. Those areas should each be approximately two-thirds the size of the eye boxes.

- Keep in mind; the spacing will differ depending on the expression you are attempting to create.

Step #3: Divisions of the Eye

- To determine how much lid to leave on the eye, draw a line approximately one-third of the way down from the top of each eye box.

- The spacing of this line can be rather arbitrary, depending on the expression you want the eyes to convey.

- If the expression is relaxed, then you need the space of the lid a bit wider. If the expression is one of fright or surprise, then the lid space will be a bit thinner and the eye portion of the box wider so you can create a rounder, more open look to the eyeball.

- For this sketch, we intend for the expression to be relaxed, normal so that the lid spacing will be about one-third down.

- Extend each lid line slightly outside the eye boxes. This will allow for better placement of the eyebrow as we continue.

- Again, don't concern yourself if one eye box seems bigger than another. Avoid striving for perfection.

Step #4: Getting the Overall Picture of Balance

- It's always important to lean back and take in the overall balance.

- At this point, you can easily make some minor adjustments.

- A word of caution! You are only achieving balance in these preliminary sketches. Don't try to create detail yet.

Step #5: Have Fun

- I've been forgetting to add one of the most important steps—have fun!

- Congratulations! You have just created what will become a well-balanced face.

- At this point, you may want to add some roundness or some angles here and there, depending if your portrait is to be a woman or a man.

- Only add these curved or angled lines to the outside of the face to change your initial oval.

- Avoid going over and over your lines, as this will cause weight and value where you might prefer a lighter touch.

Chapter 3: Creating Expressive Eyes

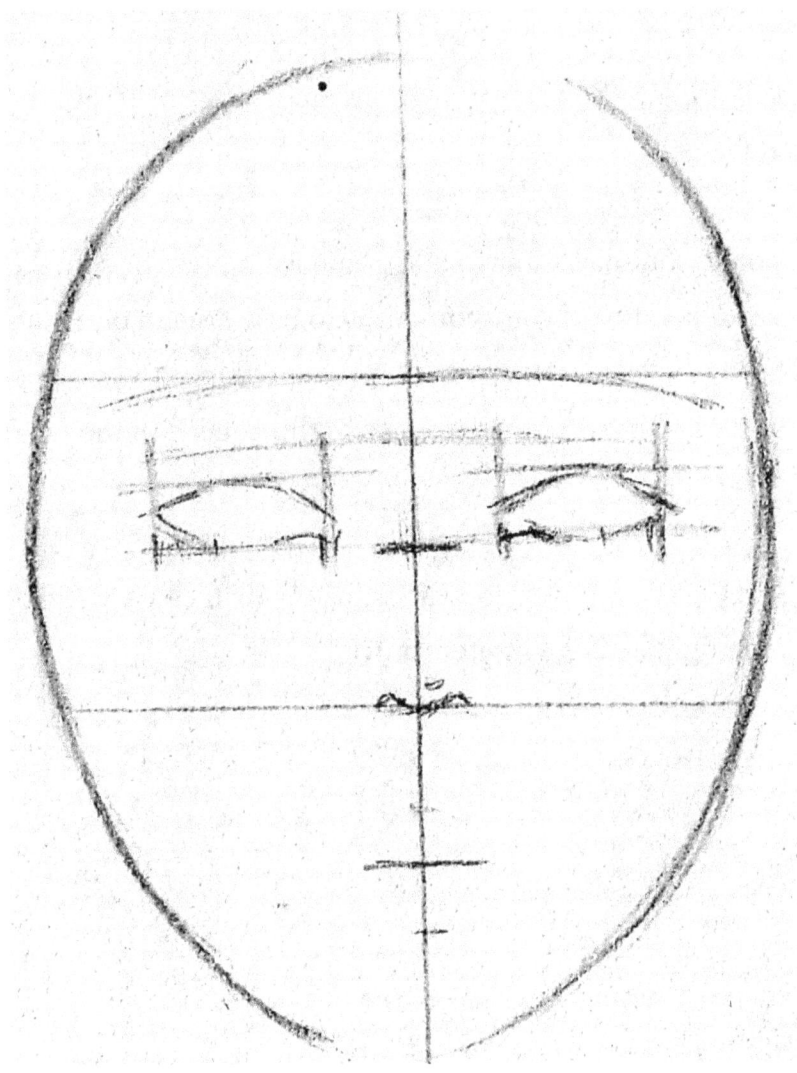

The shape of the eye in our illustration is a relaxed or normal expression. We have left room for a standard sized lid, and the eye will touch or move just outside the inner box. This is the perfect time to discuss how you can create different expressions by the shape of the eye.

For a surprised or frightened look, you will want to leave more space for the eyeball and less for the lid. This will open up the eye. We'll discuss later how the pupil, iris, and brow line are sketched and shaded, but for now, let's focus on the general shape of the eye.

For an annoyed look, you will want to make the top part of the eye flatter and team that with an angled brow. To make the face express rage or anger, you would sharply drop the top inside one-third of the eye and give that same portion a heavier hand with the pencil to emphasize the angry expression.

For a confused expression, the entire eye would be squinted and the top lid thicker. You can always practice on a separate sketch paper all the different looks you can create with eye shape and shadow.

One of the most important things is to be intentional with your spacing. Know ahead of time the expression you plan for your portrait, and then space your features accordingly. Also, keep your features compatible with one another. It would be illogical for an angry person to have soft eyes, eyebrows that express confusion, and then thinly pursed lips that signified anger.

Step #1: Creating Proper Eye Shape

- For a normal or relaxed expression to the eyes, think of them as shaped much like an elongated almond.

- Looking at the illustration, you will see that the bottom of the eyeball is deeper, moving up to meet the top.

- Avoid dragging the outside of the corner down. Doing this will make your subject look tired or sad.

Step #2: Position the Eyes

- The eyes should take up most of the sketched box space.

- As you move around the tear duct, make sure you have located it just above the bridge nose line.

- Don't worry if the tear ducks are not exactly alike. They are meant to be different.

- Notice how the lines are heavier on the top than the bottom. To avoid creating solid lines, use shorter strokes. You can also use a pencil eraser to smudge the lines a bit so they look more realistic.

Step #3: The Realistic Approach

- When you lean back to get the fuller picture, the eyes will look different. That's fine. There will be much more detail later to pull them together and create balance with shading and light.

- Only make the slightest promise of a line with your pencil at the corner of the duct, and be sure you use short, rounder, softer strokes.

- When using the pencil eraser, keep your touch light. You don't want to remove very much of the sketching, just a slight dab here and there will do the job.

- Up to this point, we have used a #4, #5, and #6 pencil. When using graphite pencils, the higher the number, the lighter the mark will be. This being the case, you'll need to use a #4 pencil in the areas where you want a heavier line.

- When sketching the eyes, the softer and rounder you can make your strokes, the more natural the eyes will appear.

Chapter 4: Natural Looking Pupils, Lids, and Brows

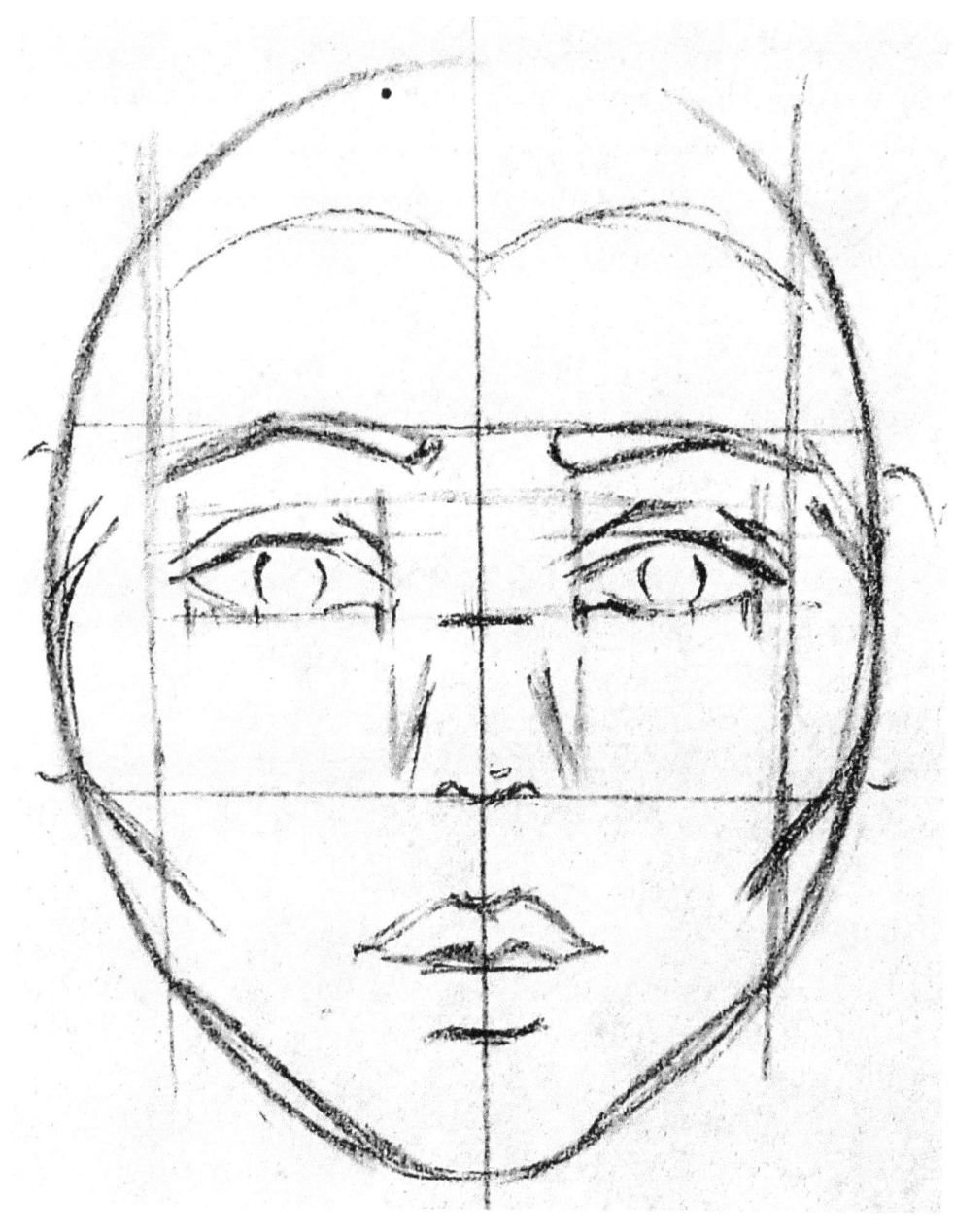

At this phase of your drawing, your focus should be to create the proper space and balance between the eyeballs, pupils, irises, lids, and brows. As you add in much of the detail, you'll enjoy seeing how all these lines, circles, and boxes begin to look like a human face. The further along you get with your drawing, the more tempted you will be to rush things. Don't! Details take time and patience to get your desired effect. As a beginner, you're going to get excited to see your new creation, but continue taking your time. Spending time getting the details right might mean you don't have to make as many adjustments as you go.

Step #1: Alignment of the Features

- First, you'll need to sketch a line down both sides of the face to make sure your features align.

- The line should be fairly light so as not to interfere with your detail work.

- Beginning at the top of the head, just outside your original oval, draw a vertical line that travels from the top of the head to the outside corner of the eye, and down through the cheek and chin area.

- Do this on both sides of the face.

- This line will be used to align the eyebrows and eyes to the cheeks and lips.

- Now draw another light line from the edges of the nose to the top line of the eyebrow section. This will enable you to align the eyebrows with the nose and create balanced features.

Step #2: Drawing the Iris

- The circle that makes up the iris should cover about one-third of the eyeball area.

- Again, shorter rounder strokes are preferred. Since you want these lines to be a bit darker, use your lower numbered pencil.

- Take another close look at the illustration. Notice that the iris is not a perfect circle.

- Approximately a fifth of the iris should be covered by the eyelid.

- The outside circle of the iris should be darker to give it contour. In fact, you can leave the top and bottom of the iris almost open. Perhaps just a hint of a line.

- Use your pencil eraser to smudge the line if necessary.

- At this time, you can add a heavier liner look to the top of the eye and around the corner of the eyes' tear ducts.

Step #3: Creating a Natural Eyelid

- With your preliminary lines completed, creating a natural looking eyelid is easy.

- Just make sure you follow the shape of the eye with your eyelid line.

- Leave the inside lid line just a bit shorter than the tear duct corner.

- As you sketch the lid, make sure the eyeball line and the lid line are compatible. In other words, avoid making the lid rise or fall quickly. This will give the eye too much of a rounded or open look.

- Let your strokes follow the same soft angles as the eyeball.

- Beginning at the inside corner, with soft, gentle strokes, draw a line that reaches across the top of the eye.

- The line for the lid should contain the smaller box at the top of the eye.

Step #4: Balancing the Brow

- About the same amount of space should be left between the brows as was between the eyes.

- Starting from the inside edge of the eyebrow, using short strokes, draw a line to the top line of the middle section.

- To give the eyebrow a more natural look, its arch should occur at the same point as the outside circle of the iris.

- From that point, drop the eyebrow down just a bit to open the eye and give that relaxed expression.

- The outside edge of the eyebrow should not be drawn past the cheek lines. This will give you proper alignment and balance to the brow.

- Whatever you do, avoid making the brow too thick. Remember, and heavier brow provides you with a more masculine look.

- However, practice with some shading and some darker single hairs within the brow if you like.

Step #5: Shading the Nose

- Drawing the nose can be a bit dicey. This is where the portrait can look hard if your lines become too dark.

- All you're after is a slight shading to the nose—no hard lines. So, lightly draw a line from the tip of the nose to its bridge. The line should have a slight concave look to keep it looking natural.

- Now smudge your line. You can use a soft tissue or the pencil eraser. If neither of those gives you the look you want, just use your finger.

- Extend your nose line only about three-quarters of the way to the bridge of the nose.

Step #6: Contour the Cheeks

- Beginning approximately at the top of your eye box on the outside line of your oval, begin to round out the lines.

- If you wanted a more angular look or a more masculine look, you would want to keep your lines fairly flat in this area.

- These lines are what give you the shape of the face.

- The lines should go from the top of the eye box to approximately one-third of the lower section of the face. This will give you some definition at the jaw and chin.

Chapter 5: Detailing the Iris, Pupil, Lips, and Ears

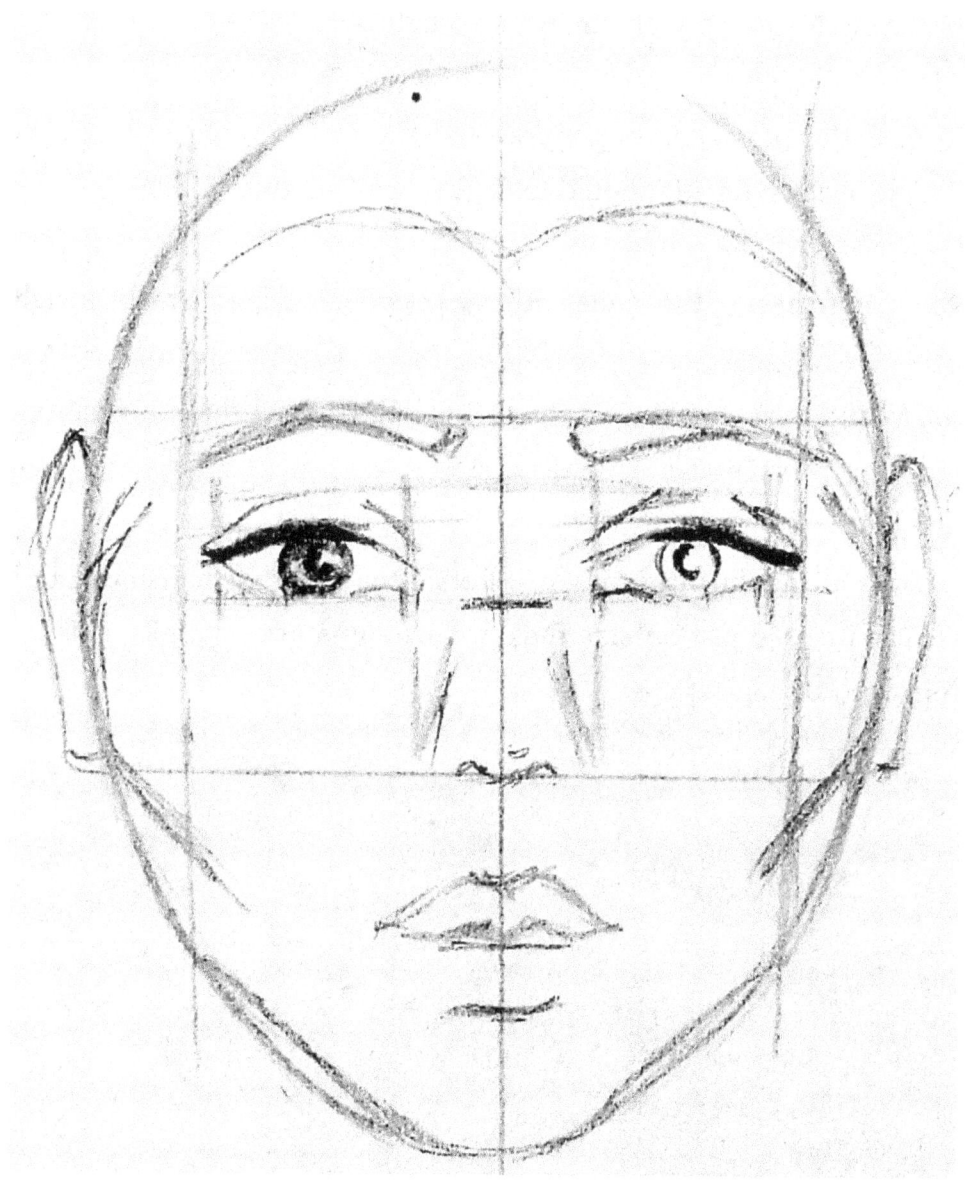

Most of this is a matter of shading, along with a few light lines to define the ears and lips. Notice that the iris has a good bit of shading, except for light left in the middle—just as light reflects off a human eye.

Step #1: Capturing the Iris and Pupil in Its Natural Light

- In the center of the iris, make a circle to create the pupil. Use a #6 pencil for the circle to keep your strokes very light.

- To give the pupil contour, darken about half or a little more of the outside of the pupil. It should look like a half-moon.

- Now, fill in most of the circle with a #4 pencil, leaving just a little light

- Shade in the iris, making it about three shades lighter. Now smudge it with your pencil eraser.

- Looking at the illustration, you'll notice that another half-moon of light has been placed just outside the darkened area of the pupil. This can be done with a pencil eraser.

Step #2: Give the Eyes Some Liner

- The heavier shading on the bottom of the lid would be used more when drawing women than men.

- Beginning just beyond the inside curve of the iris, create heaviness with a dark pencil.

- Follow the line through to the outside edge of the lid. Don't smudge this line. Leave it dark to resemble liner of thick lashes.

Step #3: Pencil in the Ears

- The ears should be drawn from approximately one-sixth of the way down from the top of the middle section.

- End the ear at the bottom line of the middle section.

- Again, keep your strokes rounded and soft, just hard enough to define the ear. Be careful that you don't make the ears too dark or thick.

Step #4: Finishing up with the Lips

- To create a pouty lip as in the illustration, make sure the outside edge of your lip does not go much past the bottom of the nose.

- To create more of a smiling or laughing mouth, you can extend the lips to a line that would be even with the center of the eye's pupil.

- A fuller top lip will reach just under half of the space between your lip line and the bottom of the nose.

- Think of drawing the lips like big bat wings.

- Notice the indention at the center—top and bottom to define the edges of the mouth.

- The bottom of the lip is a simple wavy line.

- You can darken the lips on the top center, but avoid making them too stark. Softer is better when it comes to a feminine look.

Chapter 6: Contouring the Face

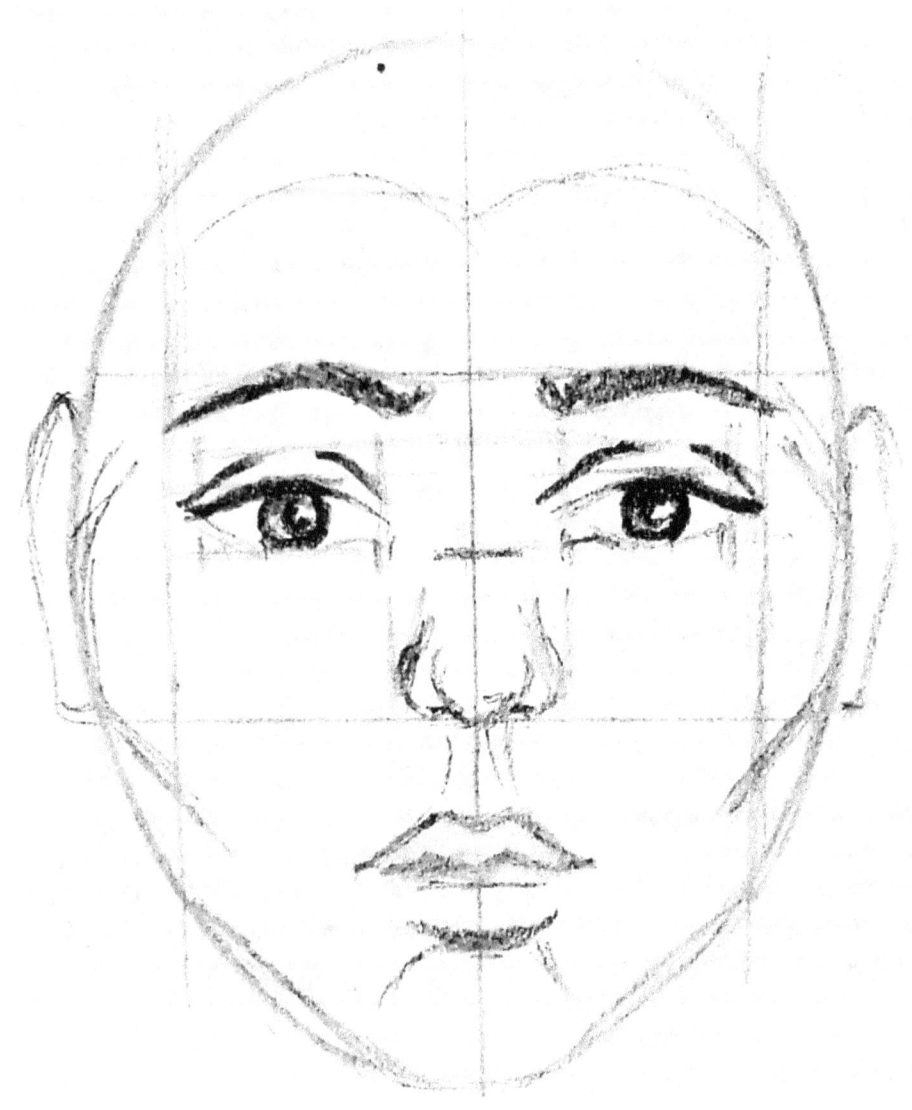

You're almost there. How do you like the results so far? It pays to be patience, doesn't it? All you must do now is a little shading around the lips, nose, and eyes and you're good to go.

Step #1: Final Shading of the Brows

- You can fill the eyebrows in and smudge them as was done in the illustration. Or, you can lighten them up and bit and draw some individual brow hairs that are darker, resembling the real eyebrow.

- This can take quite some time to create a natural look.

- Avoid making the outlines too straight. It will make your portrait look one-dimensional.

Step #2: Defining the Nose

- If you can still see your little bird wings on the tip of the nose, draw two small compressed circles. These will be the nostrils.

- Fill in the nostrils with a darker pencil.

- Now, with rounded strokes, define the nostrils. Continue the nostril line to about halfway up the previous line you made for the nose. The more you smudge the lines, the more natural the nose will appear.

- At the tip of the nose, draw a rather wide U. Smudge these lines as well to prevent your nose from looking bulbous.

- Beneath the nose, draw two light lines from the center of the nostrils to the points of the upper lip.

- Smudge, smudge, and smudge!

Step #3: Finishing the Lips and Chin

- Darken the lips with short, more angular strokes. This will give the lips more definition.

- Draw the line to the bottom lip from the original lip line to just under one-third of the way down the lower section.

- Now shade the top and bottom of the mouth, keeping the corners from touching. If you're not careful, drawing lips that touch at the ends can appear clownish.

- Just a few chin lines and your portrait sketch will be complete.

Chapter 7: Creating Expression & Strength

Now that you have worked through the first sketches, getting a feel for spacing, size, balance, and shading, let's add some finer details to provide expression and strength to your sketch. We'll also work with the male face this time to illustrate how sharper angles and subtle shading can portray male characteristics.

Comparing the two sketches, you will notice that this one contains more shading and light, darker lines to define the top of the head, around the ears, the chin, and neck to give the sketch value and depth. This eludes to a more dominant and powerful male figure. The play of light and gentle shading also has been added to define more angles around the cheeks and along the throat.

Viewing the difference in these two sketches, it is easy to distinguish between the male and female face. Also, the first sketch is almost expressionless, as we have focused on how to make your sketch balanced. With this sketch, we will review balance, and then move on to illustrate how to add expression.

You will notice that the first sketch is rather flat with not real affect; however, the male drawing looks as if he is about to reach out from the page and say something. This has been purposefully created by the play of light and shadow.

Let's break this sketch down, much as we did the first, and examine it step-by-step to see just how this expression was achieved, shall we?

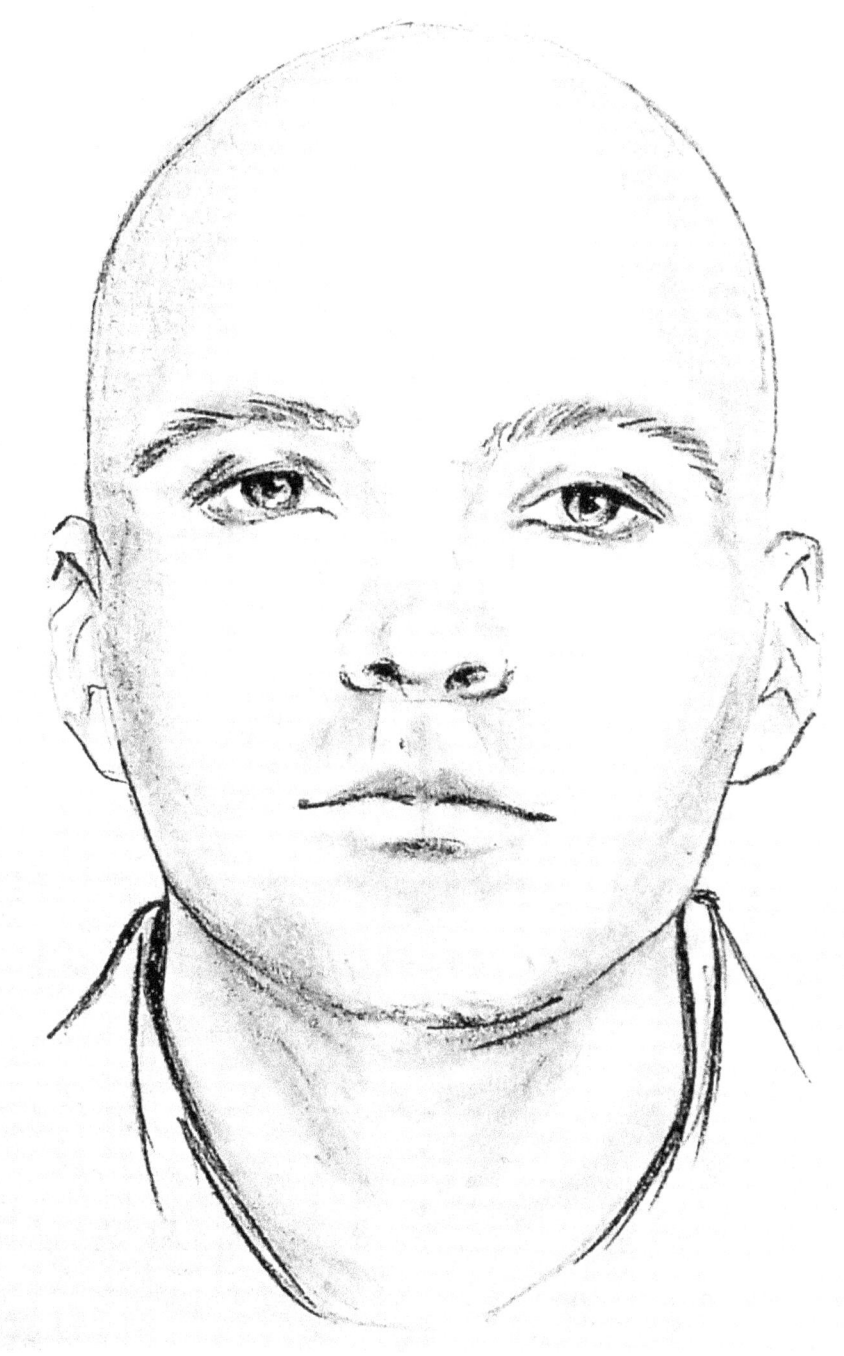

Step #1: Spacing the Features

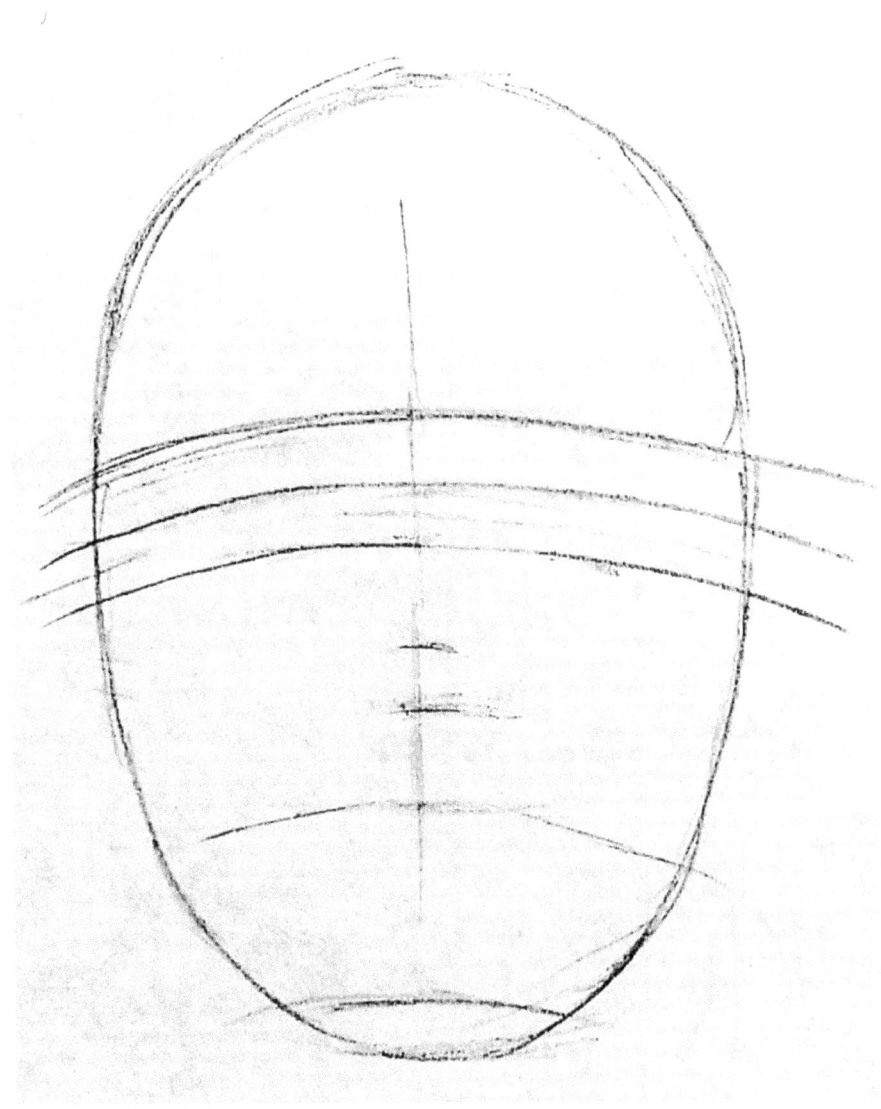

- Notice the shape of the head has been elongated, giving us more opportunity to make the face leaner and more angled to appear more masculine.

- We continue to divide the oval shaped head into thirds so that our features can be appropriately balanced. However, realizing that our

subjects will have different face and feature shapes, we have allowed a bit more space at the top of the head on this sketch. In doing so, we have shifted the weight of the sketch. We have also reduced the space on the chin and jaw line.

- Just as in the other sketch, the middle third will contain the eyes, nose, cheeks, and ears.

- The bottom third will define the mouth, jawline, and chin.

Step #2: The Middle Section

- Find the center point of the middle section and draw a short dark line. This will represent the bridge of the nose.

- Split that section again, from the bridge line to the top line of the middle section. This will be the eyebrow placement and the spacing for the eyes.

- At the bottom line of the middle section, draw a short line directly below the bridge of the nose. This will become the tip of the nose.

Step #3: The Bottom Third Section

- Approximately half way down the bottom section, in line with the tip of the nose, draw a line about the same length as the tip of the nose. This will be the center line of the mouth.

- I have added a few markers on this portrait to remind myself to strengthen the chin by making it shorter and giving it less of a curve. This will become the chin line.

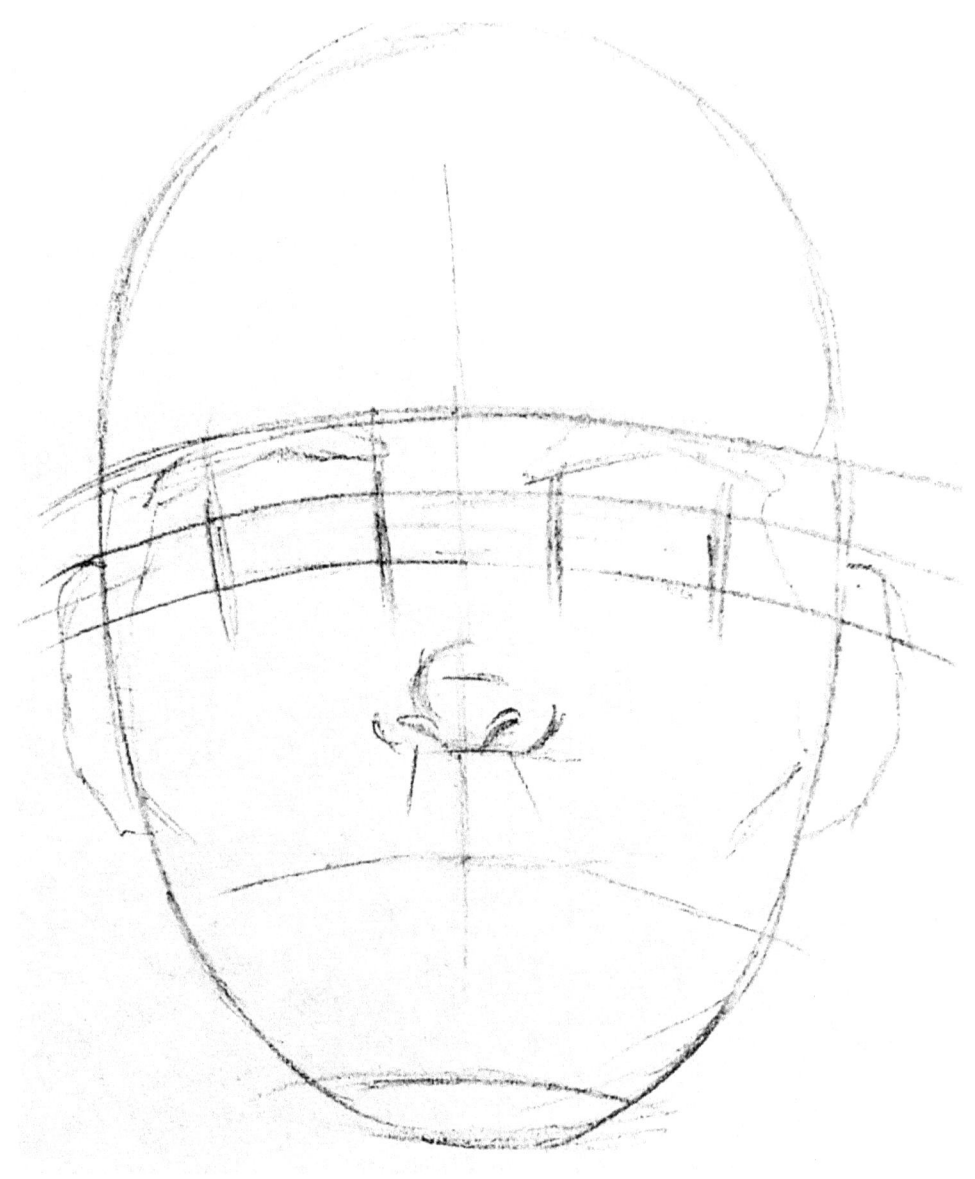

Step #4: Spacing the Eyes & Brows

- Looking at your middle section, the line you drew for the tip and bridge of the nose should be the same width; for our purposes in this portrait about an inch. If you want the eyes to be set farther apart make your bridge and tip of the nose line longer. Likewise, if you want the eyes to be set closer together, make your bridge line and tip of the nose line shorter.

- Now, extend a line from the tip of the nose to the top line in the middle section.

- Draw another line running through the cheek line to the top line in the middle section. Do this on each side of the face. This will begin to form your eye boxes, as we did before.

- Now erase the extending lines so as not to confuse your sketching.

- You should clearly see your eye boxes. The eyes should be positioned about the same width apart as from the end of the eye box to the temple.

- On this sketch, we want the eyes to be narrower and the brow line to be higher and thicker, to show the masculine side.

- Keep in mind, the eyebrows don't have to be even, and they can extend a little beyond the eye box.

Step #5: Nose & Ear Placement

- For this sketch, we're going to draw the nose with a broader base than before. Notice the nostrils are a little flared as well.

- The ears will be a bit broader, so make them wide enough to add details later. Also, you will notice they are shorter in length. This is especially important if your subject does not have hair.

Step #6: Adding the Details

- Following the instructions from Chapters 4-6, draw in the details to the eyes, keeping in mind that you will not need to line the lids as heavy.

- You will also be adding angles along the cheeks for strength in the features.

- Notice the mouth is wider, and the top and bottom lips are thinner. So, extend the mouth a little past the center of the eye, and leave more space between the tip of the nose and the upper lip.

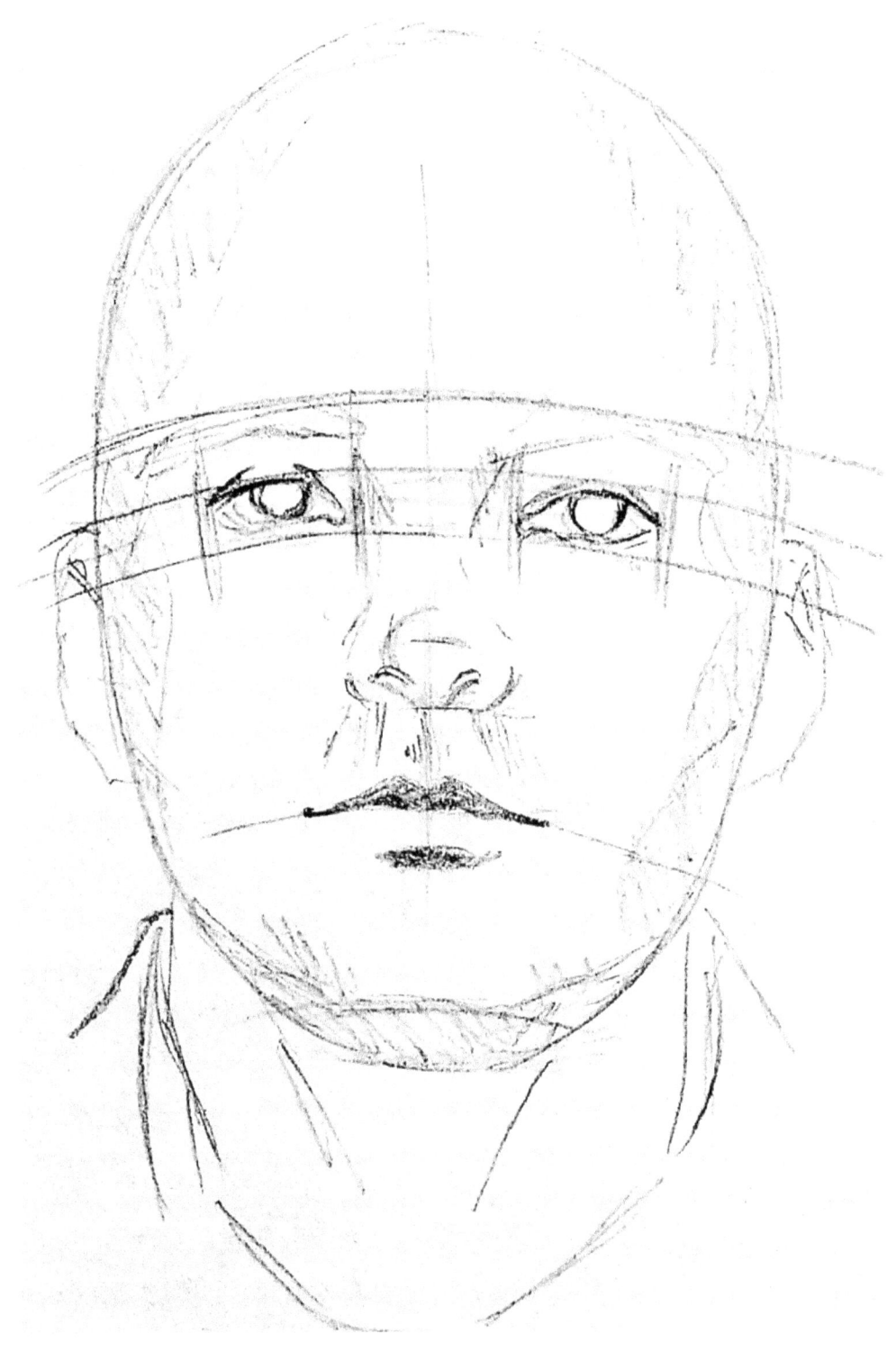

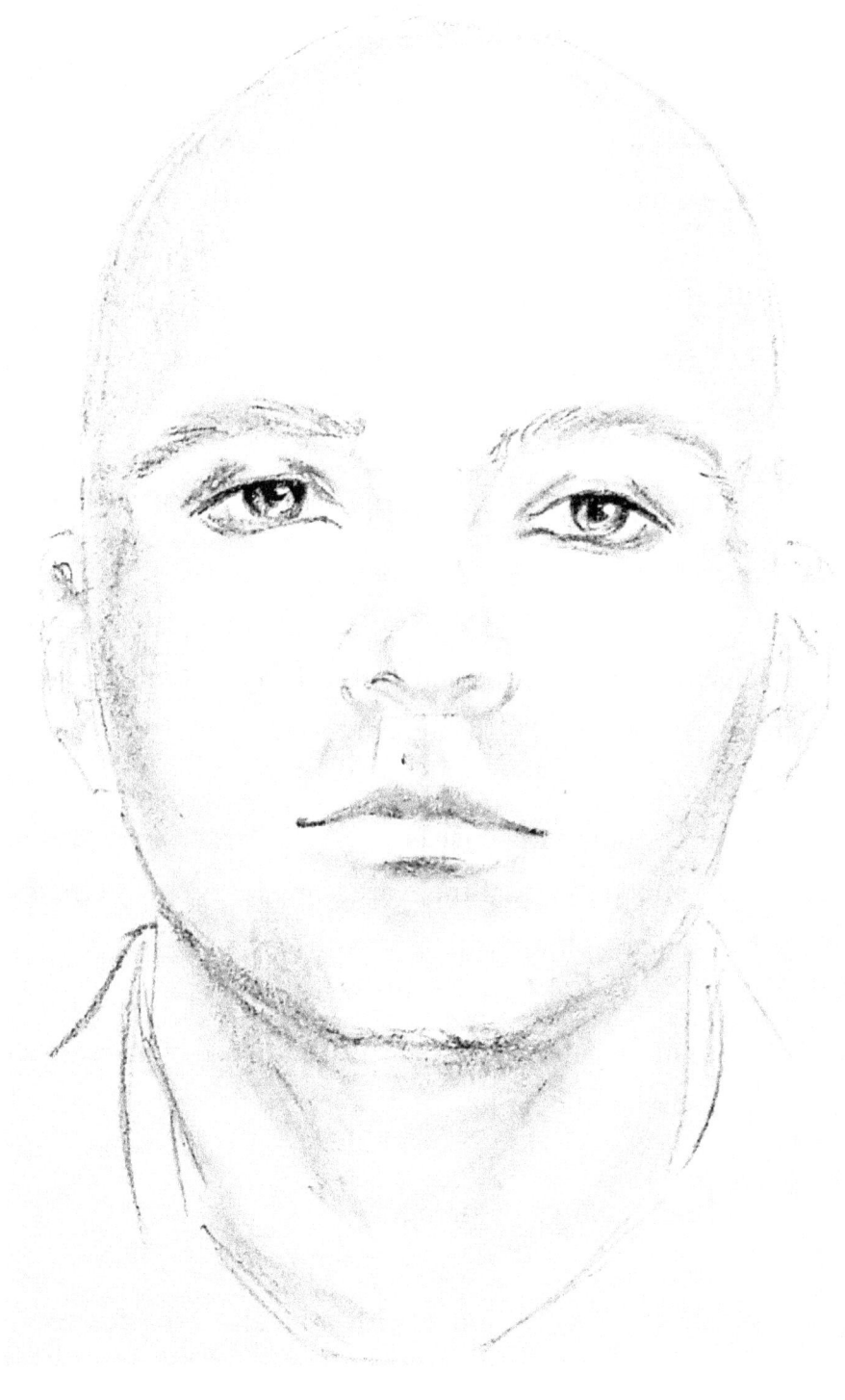

Step #7: Contrasting Light and Shadow

- Looking at the crown of the head and down the forehead, you will see that soft shading has been done to add contour to the head.

- Using a #4 pencil making some short, soft strokes that can be smudged. Because the space is larger, you may want to use a tissue to smudge instead of an eraser. Don't be afraid to experiment to see what affect you prefer.

- At the temples, the shading goes completely to the end of the brow line. Make sure you soften it to just a hint of a shadow as it gets closer to the eyebrow so that there is definition to the brow. Add in a few darker strokes to the brow so it gives the appearance of hair.

- Shading continues down the cheeks and gets darker as it progresses to the chin line. You'll notice that there are some fuzzy, curly strokes on the chin to portray a hairy chin.

- There is also shading beneath the nose, with the use of an eraser to bring light to right above the upper lip.

- The chin has been squared for strength.

- As you contour the neck, smudge with a small tissue for control and stroke your fingers inward to leave light in the center of the neck. Now take your eraser and move it gently across the neck to create the illusion of light.

Step #8: Finishing Touches

- Step back and look at your portrait.

- Add light where necessary to lift the features outward.

- The more shading you remove, the broader the face will look.

- Soften the lines around the chin, leaving just enough for definition but not so much that it looks as if it's been perfectly penciled.

- Don't forget to keep the light in the eyes for expression.

- If you need to darken here and there in the eyebrows or beneath the eyes for shape, you can always add it now. Be careful not to make the eyes look as though they are lined with makeup.

- You may have to go back into the eyes and do more smudging. This should be done with a pencil eraser for finer work.

- If you want that sleepy, more sensual masculine look, droop the eyes as has been done in the sketch provided.

- You'll notice that we have given the appearance of the head jutting forward a bit. This is done by showing much of the neck and lifting the chin.

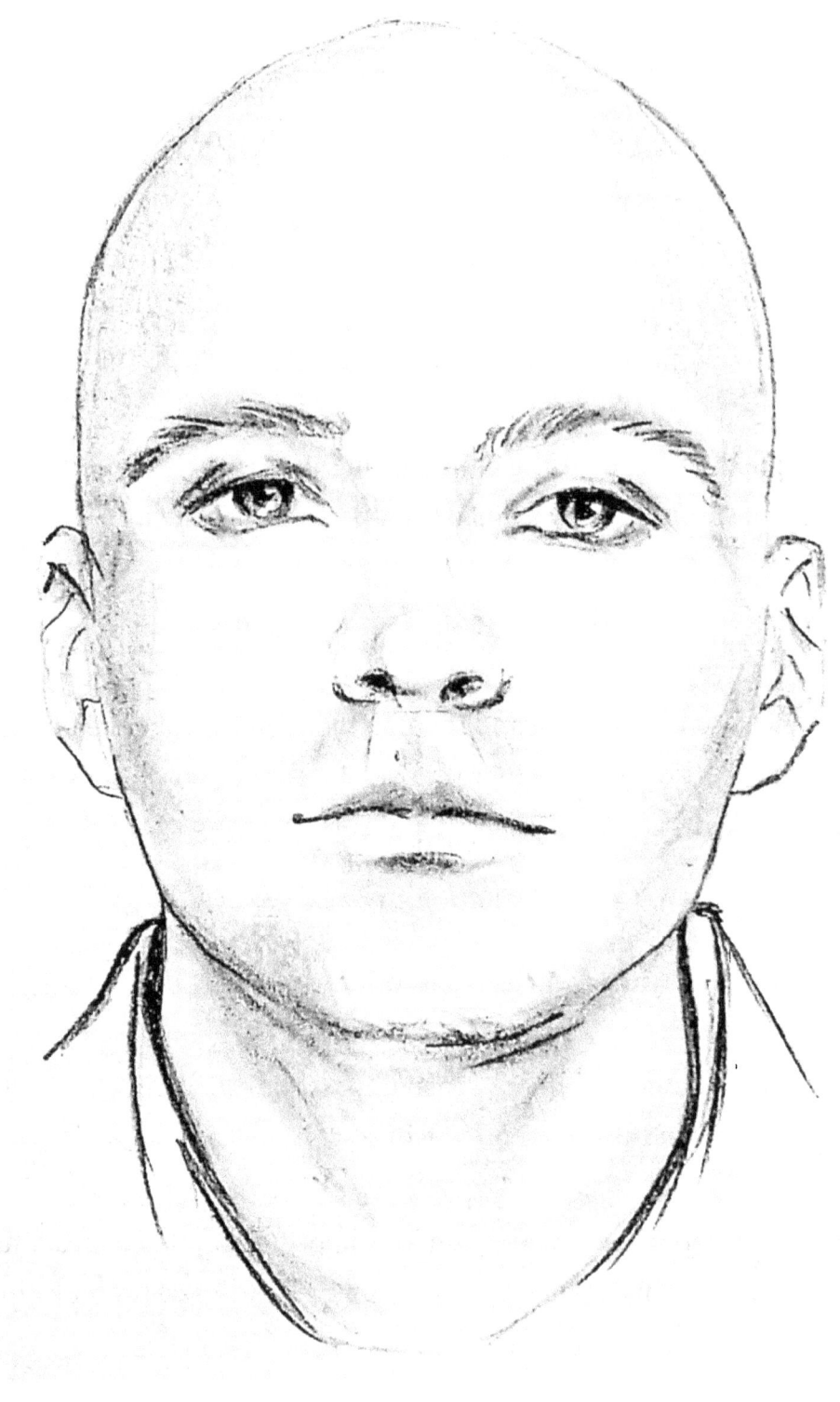

Chapter 8: Over the Shoulder Pose

Are you ready to challenge yourself with an over-the-shoulder portrait? Spacing, light, and shading is everything when it comes this pose.

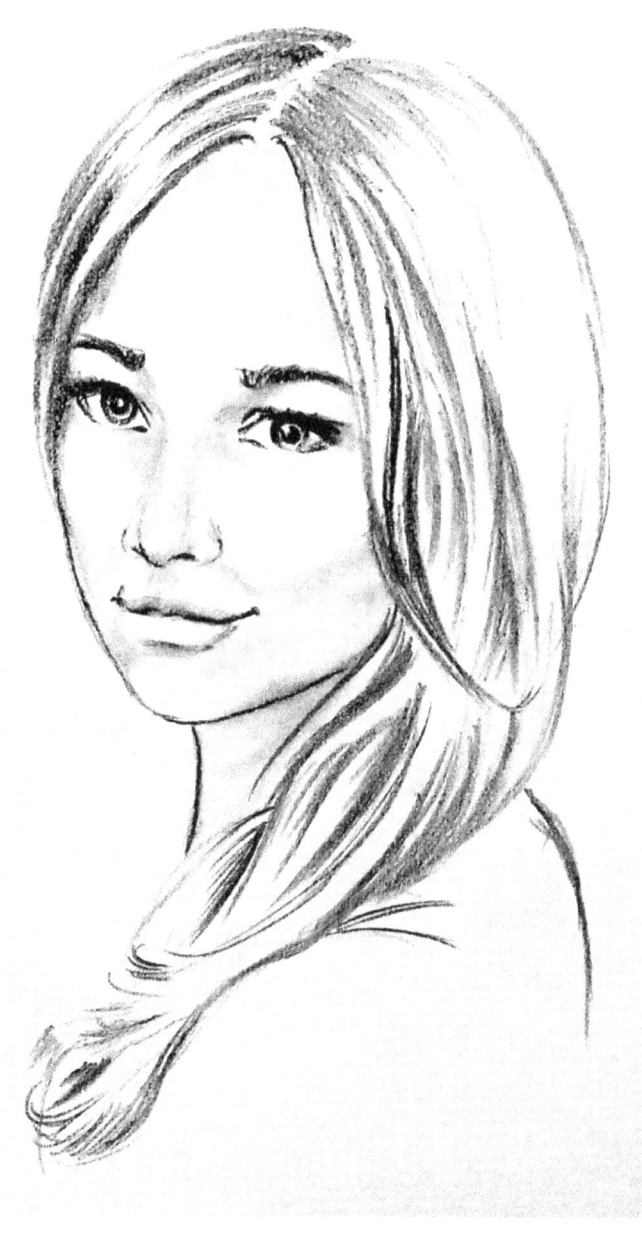

Step #1: The Head Tilt

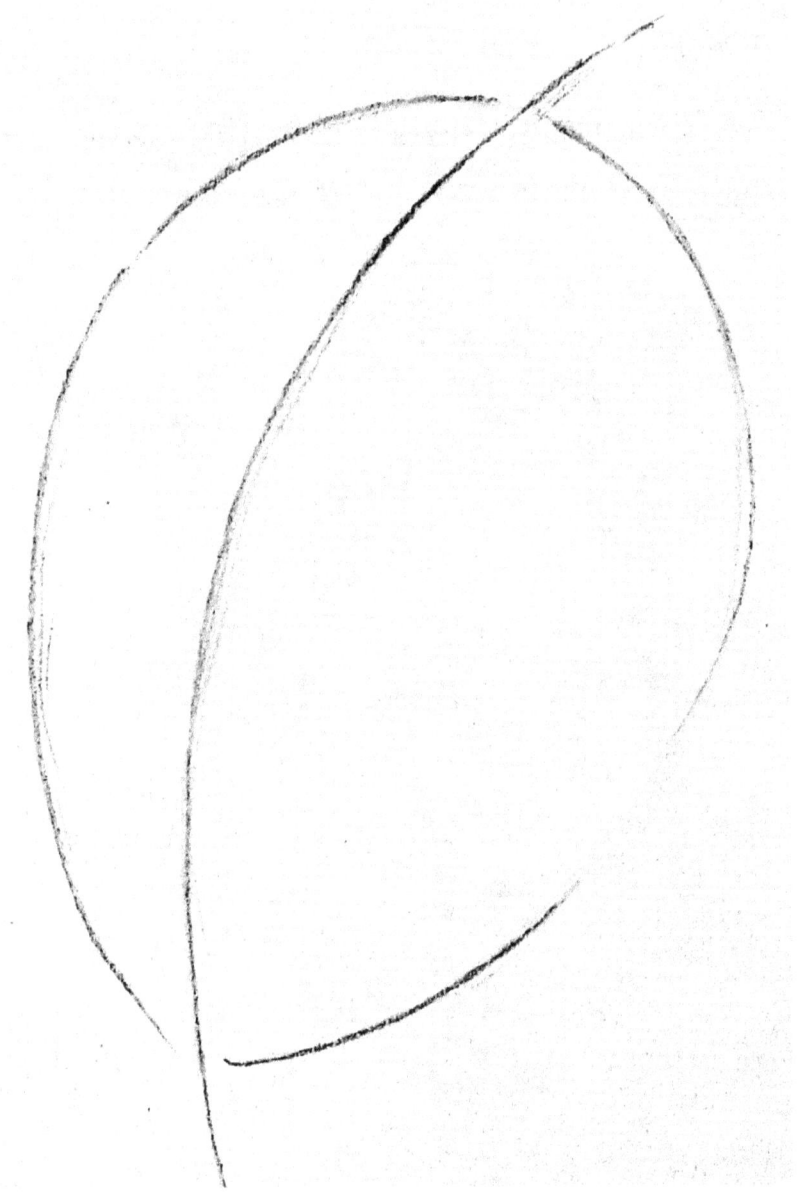

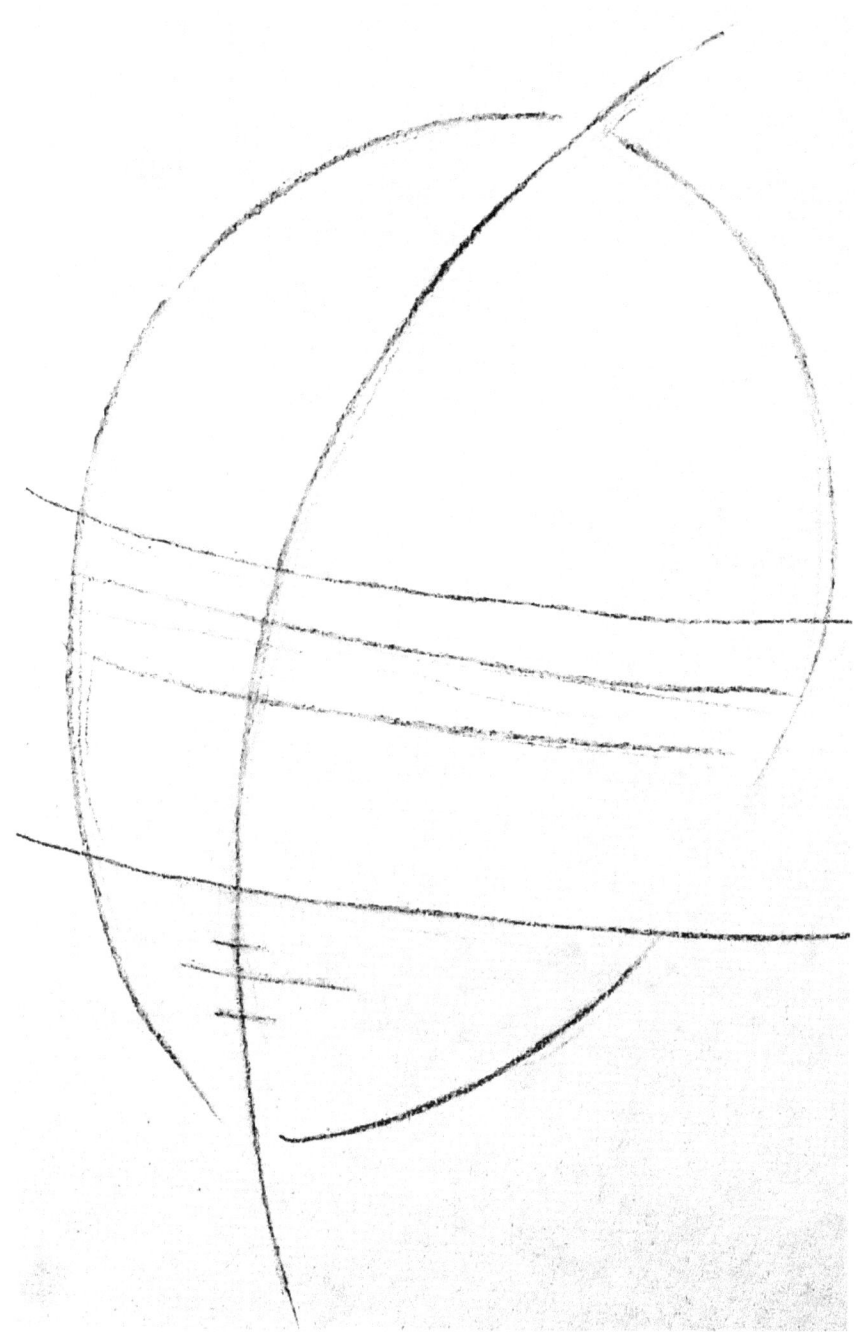

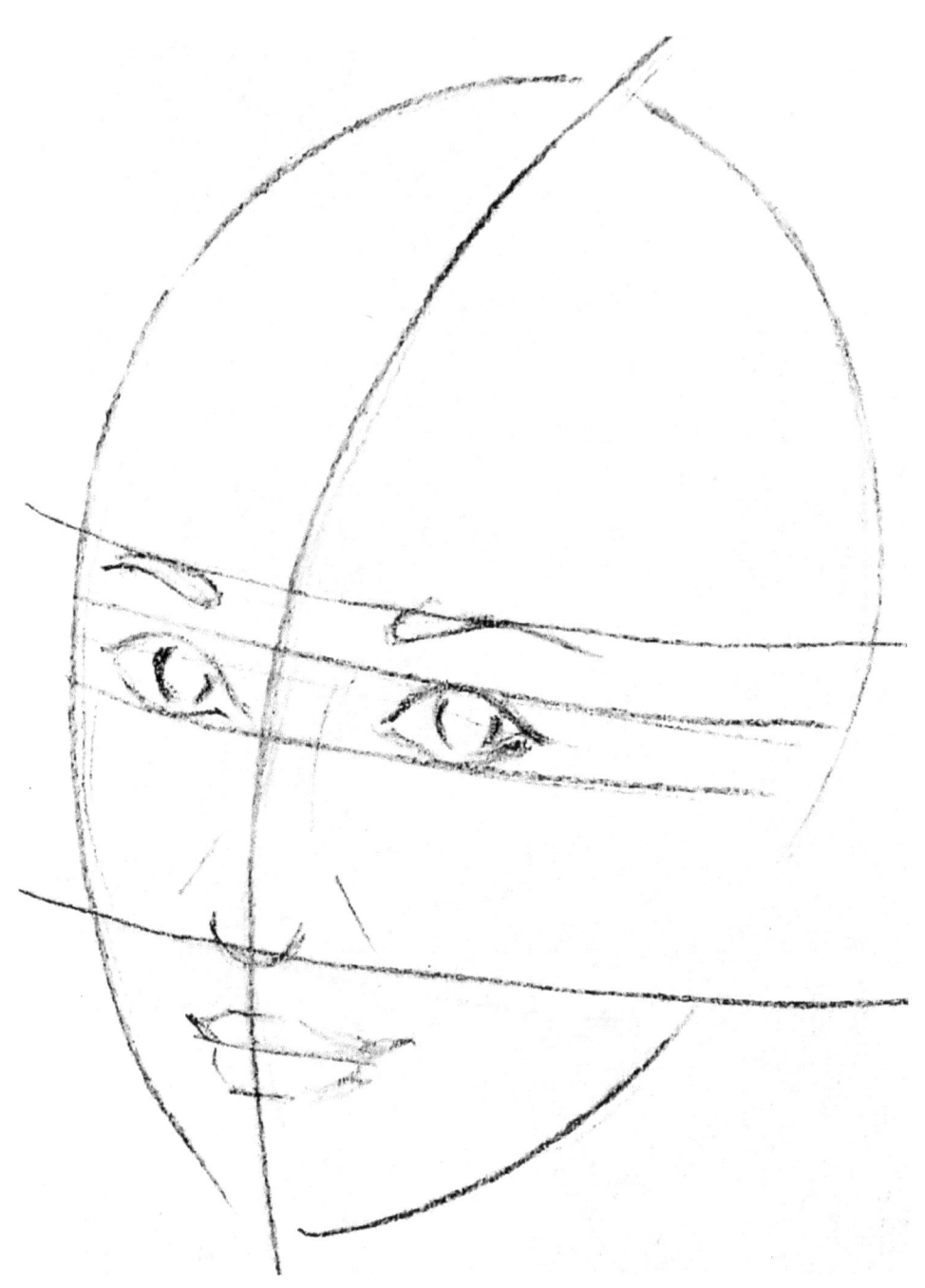

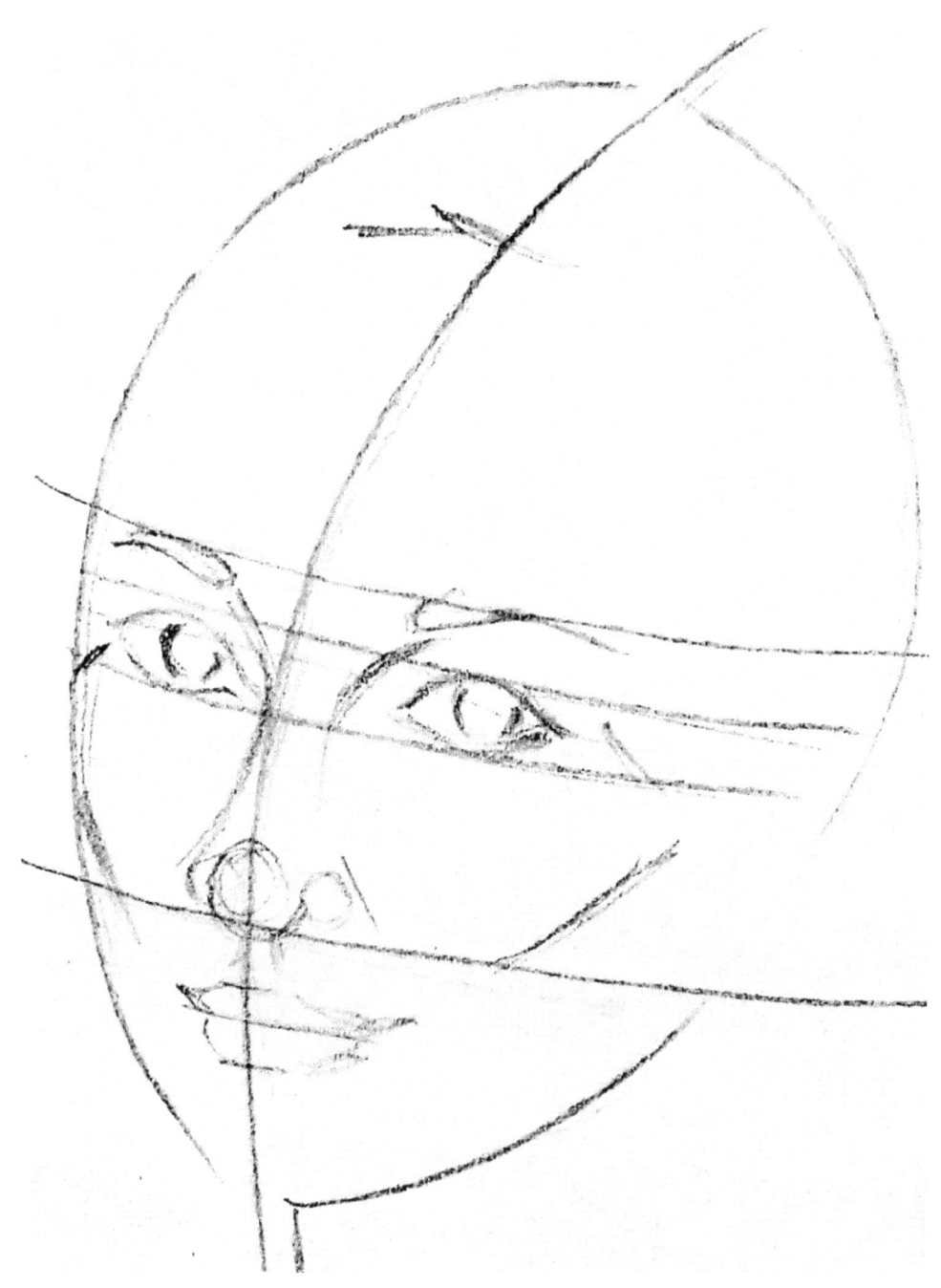

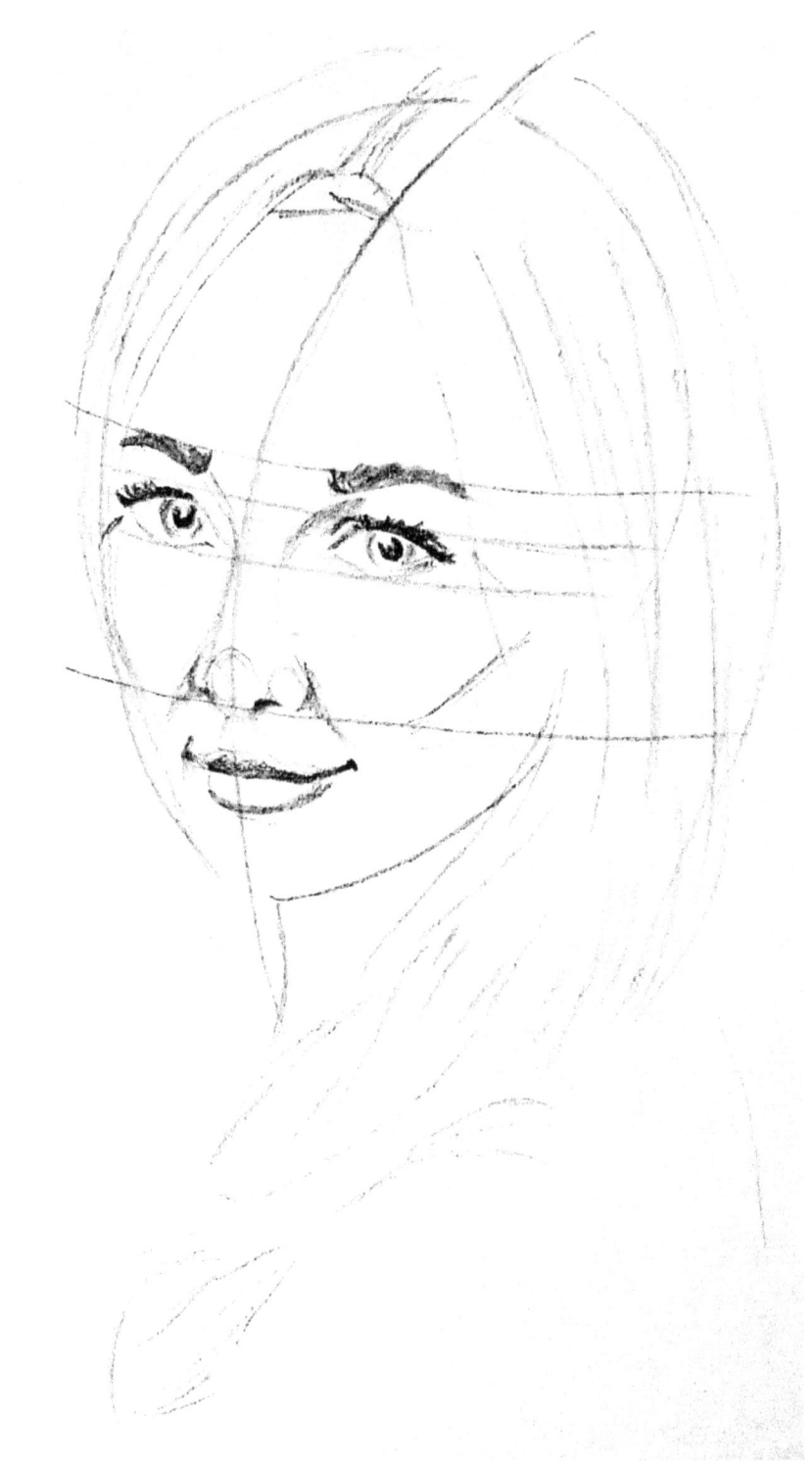

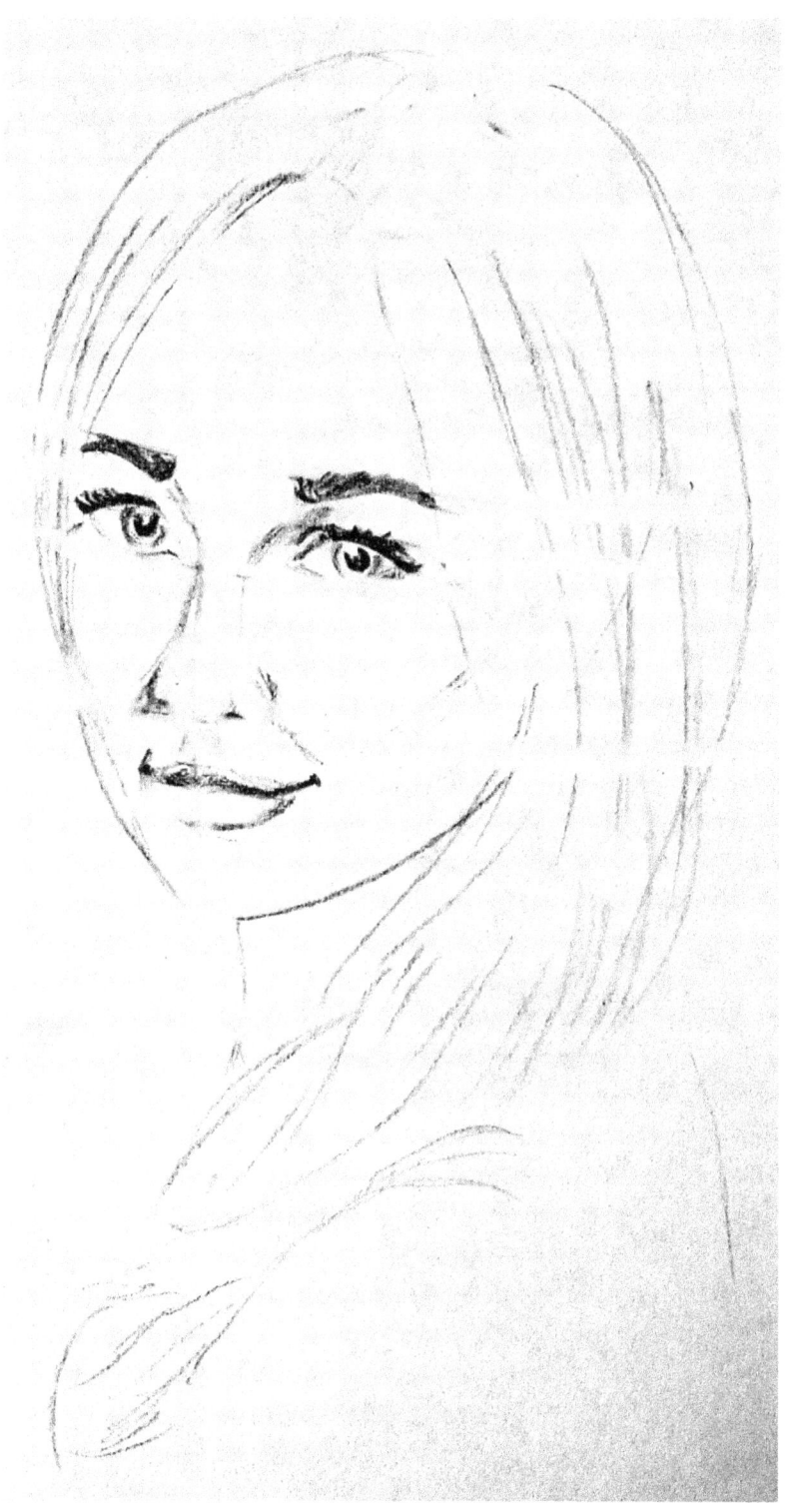

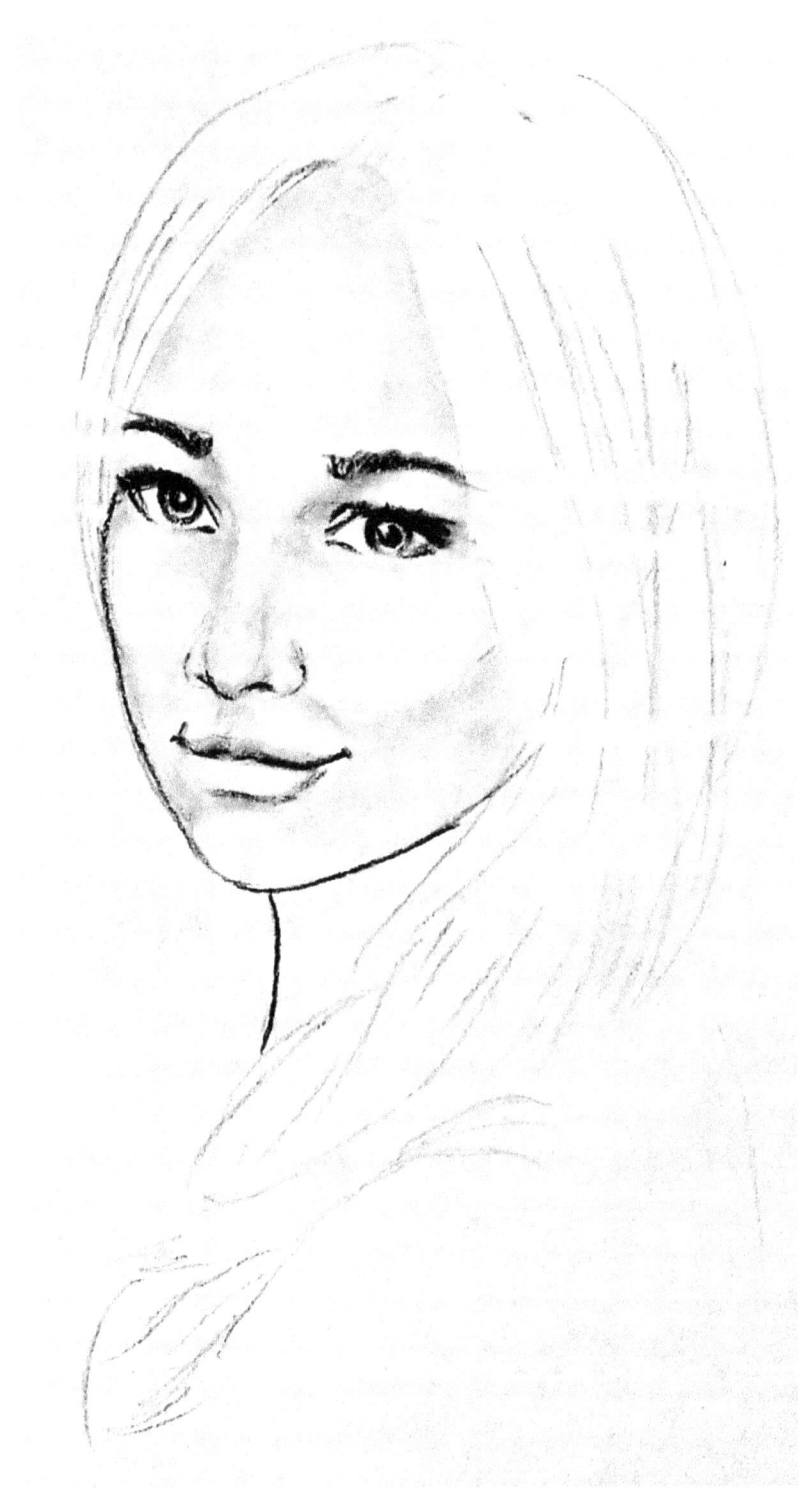

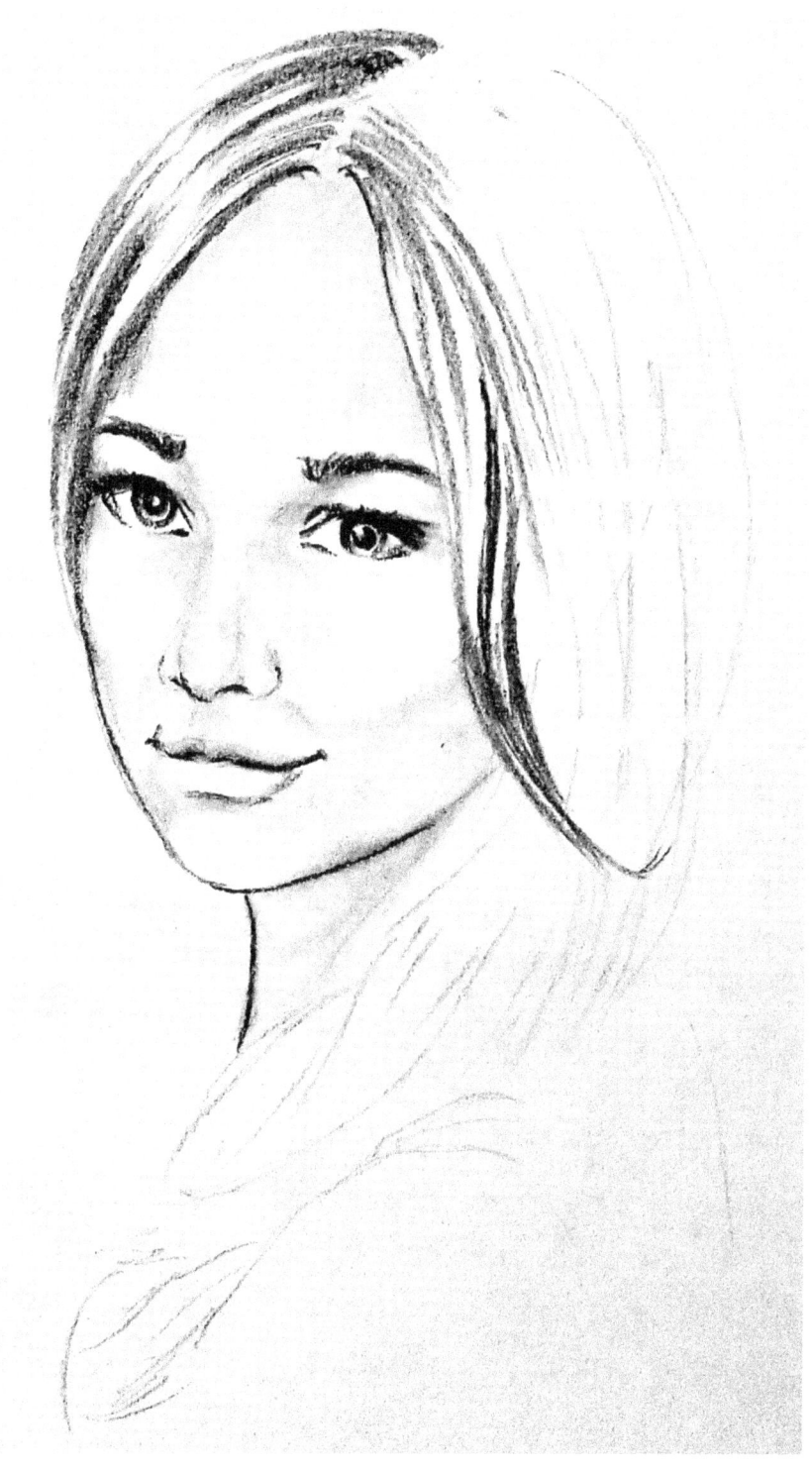

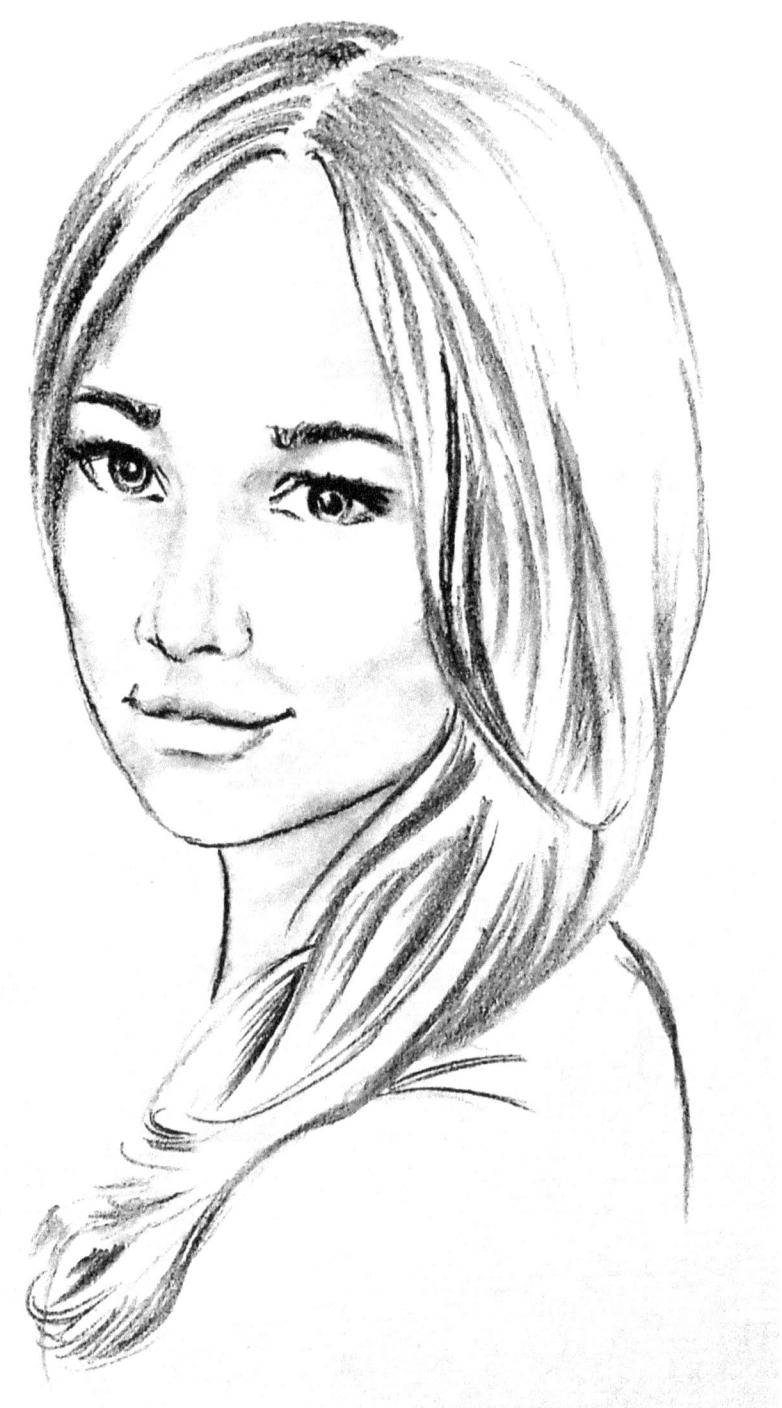

- The tilted head is achieved by first making the shape more like a football.

- Then, instead of drawing a center line, divide your head by one-third to one side and two-thirds to the other.

- Curve the line like a third moon.

- You will still divide the head into thirds—top, middle, and bottom.

- Now center your features on your vertical line, but your eyebrows, eyes, nose, and mouth will be aligned with your vertical line, which is now off-center.

- As you make the mouth line, it will be a little longer on the two-thirds side.

Step #2: Creating Balance in the Features

- You will align your eyes for the eye boxes as before, but all will be off center because your vertical line is no longer in the center of your oval.

- Notice the left and right eye tear ducts are aligned with the corner of the nostrils, but everything is weighted two-thirds to one side.

- You will also need to position the irises where the one located on the one-third side is directed closer to corner of the eye. This will make the subject to be looking over her shoulder.

- The eyes are heavy lidded, but the irises reveal more of the circle to open them and create roundness.

- Your lips are still centered on the inside edge of the iris. This will keep everything in balance.

- You will also notice the shape of the chin is a bit pointed, and the cheek bones are more pronounced.

- Pay attention to the shading. Experiment with tissues and pencil erasers.

Step #3: Sketching the Hair

- There is no ear on the narrow side of the face. Simply sweep the hair back as if it were covering the ear.

- The part in the hair should follow the center of the nose. Use a soft pencil and the pencil eraser for smudging. You can make the part clearer by pressing harder with the eraser.

- The texture of the hair is created by using two to three different pencils (#4, #5, #6). Some lines are very dark, and some are lighter gray, and then some can barely be seen. Draw the ones closest to the face darker for definition.

Step #4: Defining the Neck, Shoulder & Breast Line

- The chin, cheek, and neck line are quite dark to create definition and weight.

- The neck line should be drawn just off the center of the jaw line, with a slight curve inward until reaching the hair.

- The back line meets the hair and drops down; it contains a slight curve outward to resemble the position of the top of the shoulders.

- Notice the shoulder is defined by two connected lines that form a sideways V. These lines should go to about the center of the space between the hair and the back line.

- Just a slightly rounded, broken line in front to indicate the breast line. Smudge it slightly so it is not dominant.

Step #5: A Word About Shading

- A good deal of the shading is done on the larger two-thirds side of the face.

- The cheek is lifted by shading beneath for contouring.

- There is a bit of shading on the narrow side of the face to give the hint of a cheek. A word of warning here, if you exaggerate your shading on the narrow side, your face will begin to look off balance.

- Even the inside of the eye on the two-thirds side is shaded a good deal more, as well as the neck line. The shading uses sweeping strokes to the center of the neck.

- Then lightly use the pencil eraser to give the appearance of a little light.

Step #6: Problem Areas

- Typically, the nose in an over-the-shoulder pose is what gives the artist the most challenges.

- To keep your portrait well proportioned, make sure the corner of the eye on the narrow side is even with the tip of the nose—not the edge of the nostril.

- Then, sketch the nostril on the narrow side more narrow than on the fuller side. Remember, much of the nose on the narrow side is not exposed.

- The line of the nose on the narrow side should be lightly shaded—no heavy lines. To get this affect, you will need to be patient and practice your smudging and shading.

Chapter 9: The Slightly Tilted Head

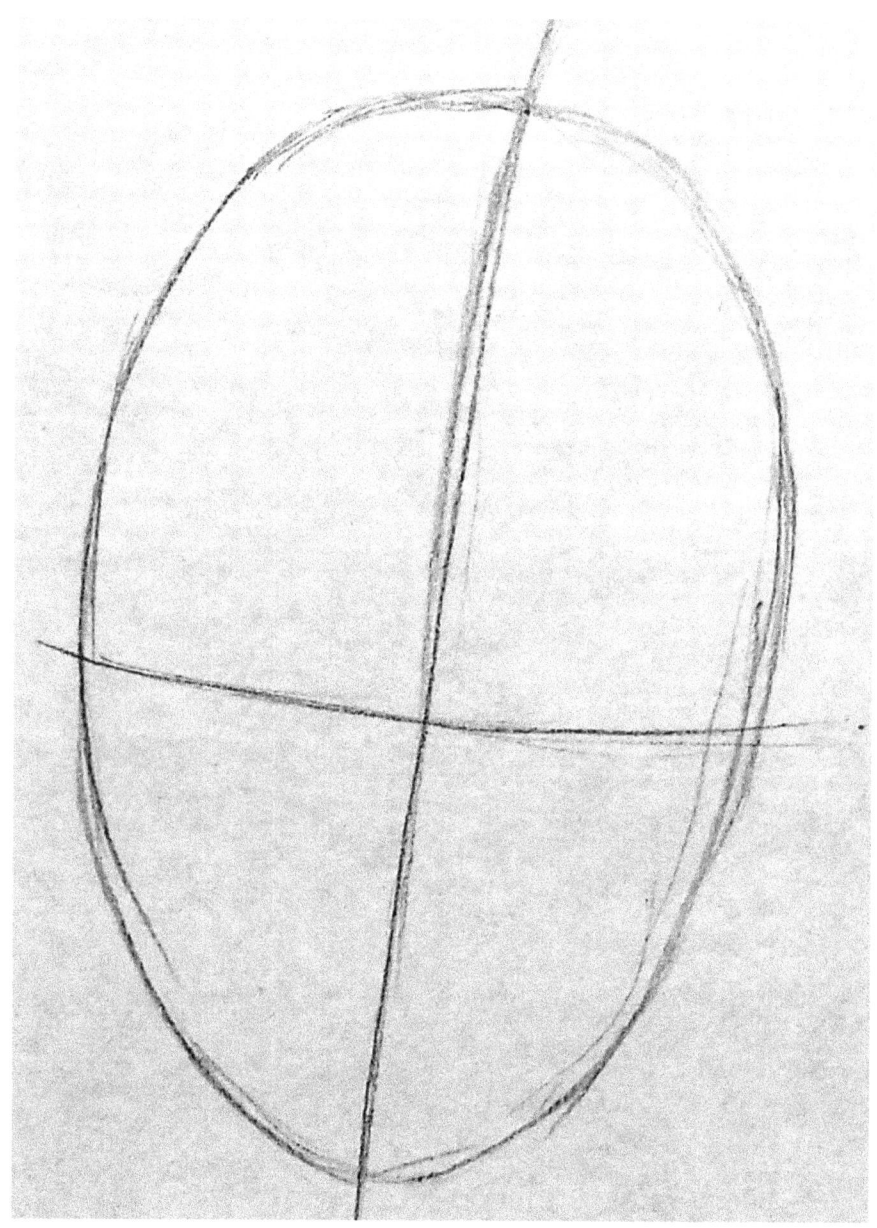

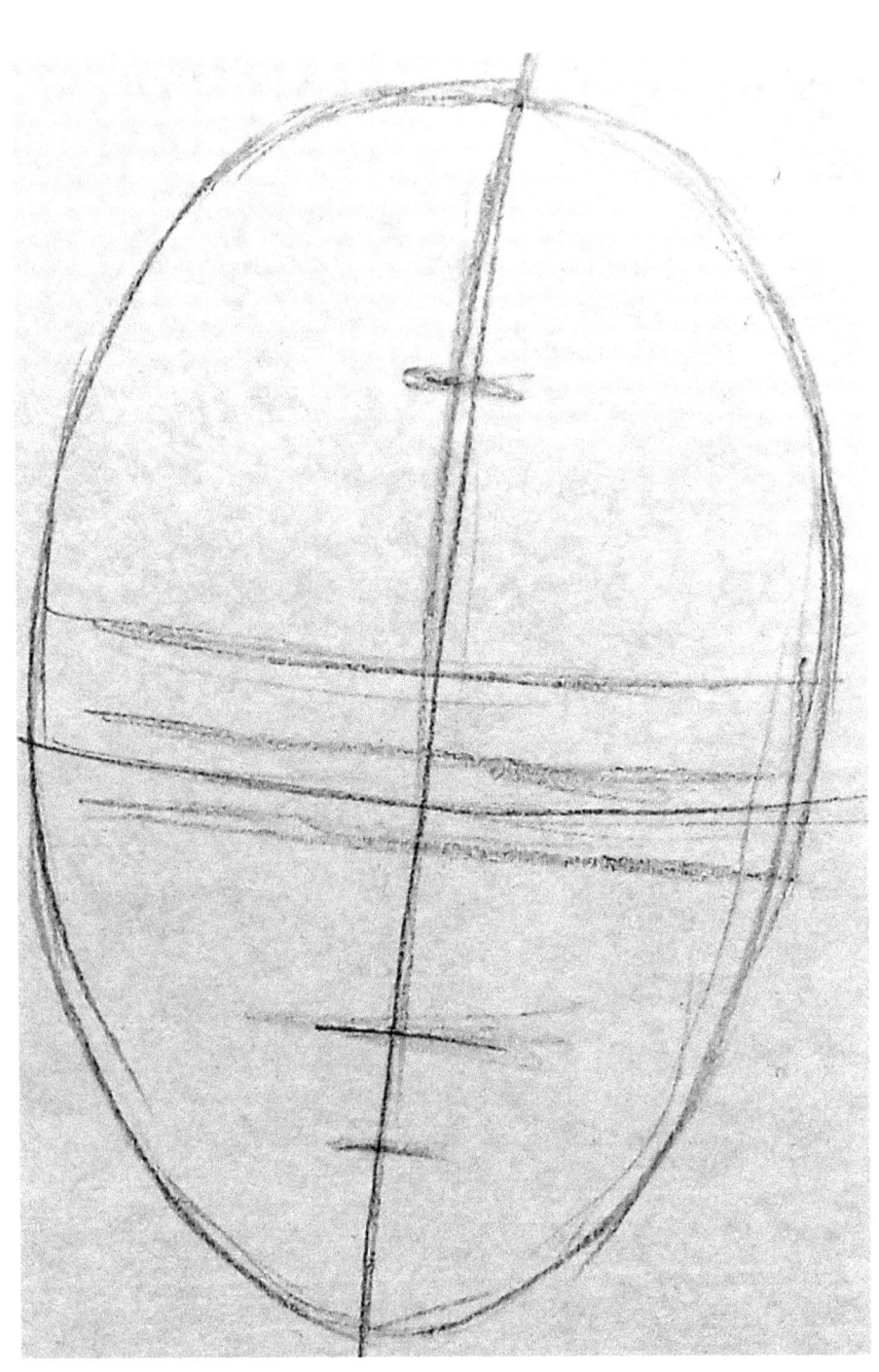

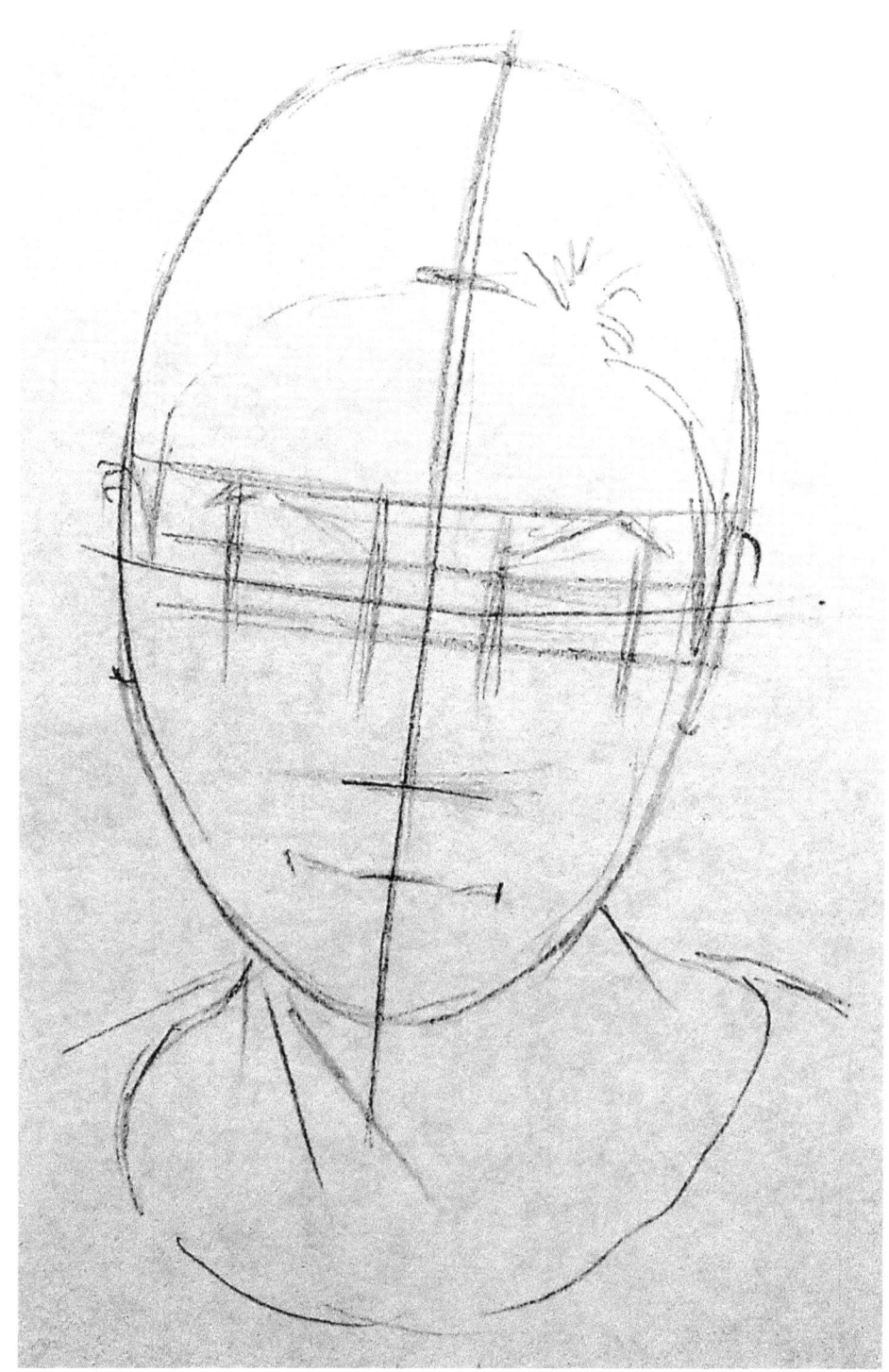

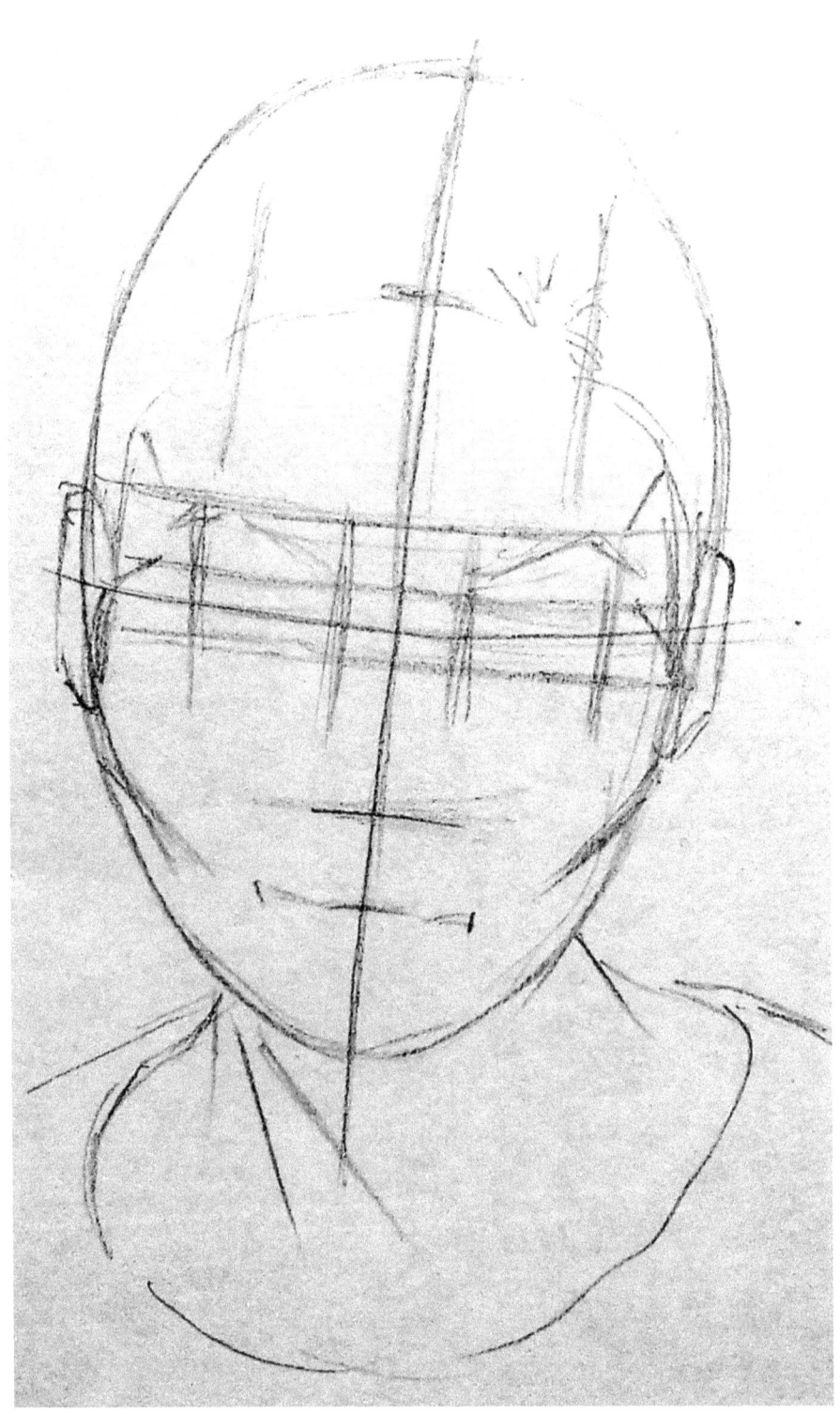

Step #1: Finding Balance in Your Vertical Line

- Again, this is more of an oval head.

- What makes it appear to tilt is your vertical line, which should be drawn just a bit off center. Too much to one side, and your portrait will not be balanced.

- The vertical line should also have a very slight curve.

- The tilt of this head is very slight, so your vertical line and curve should not be too exaggerated.

Step #2: Balancing the Features

- Divide the head into thirds as before, keeping everything centered on the vertical line. The curve of the vertical line will give you the tilt.

- As you sketch the lines down the cheeks, you'll notice that your fuller side will have a little more space at the temple. Just slightly more though. Too much of a curved vertical line will exaggerate your spacing and throw all your features out of balance—unless, of course, you are looking for more tilt to the head.

Step #3: Alignment

- As you draw your vertical lines to align the features of your portrait, you'll want to erase them after you have completed the eye boxes and eyebrows. This will minimize confusion as you continue filling in the details.

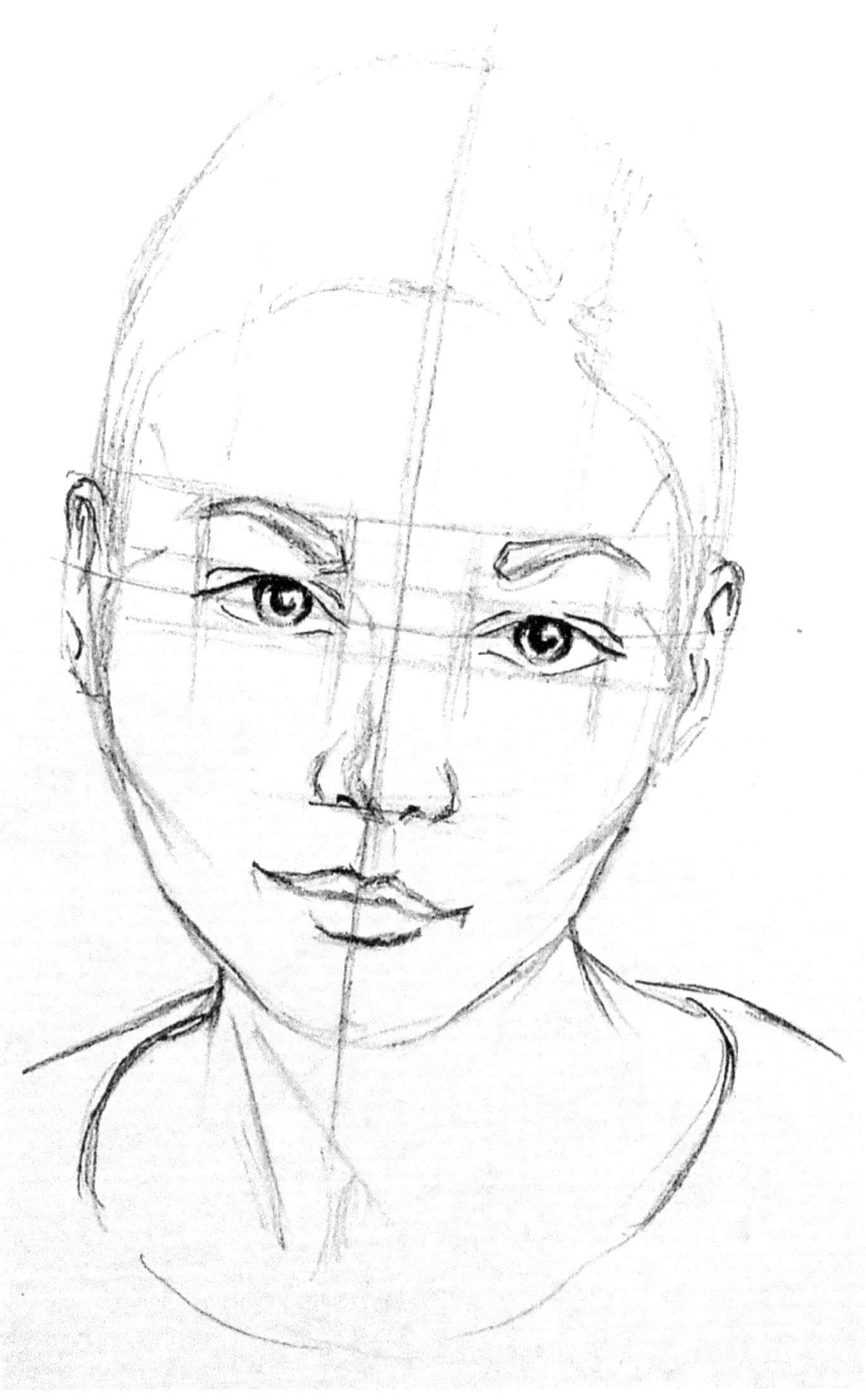

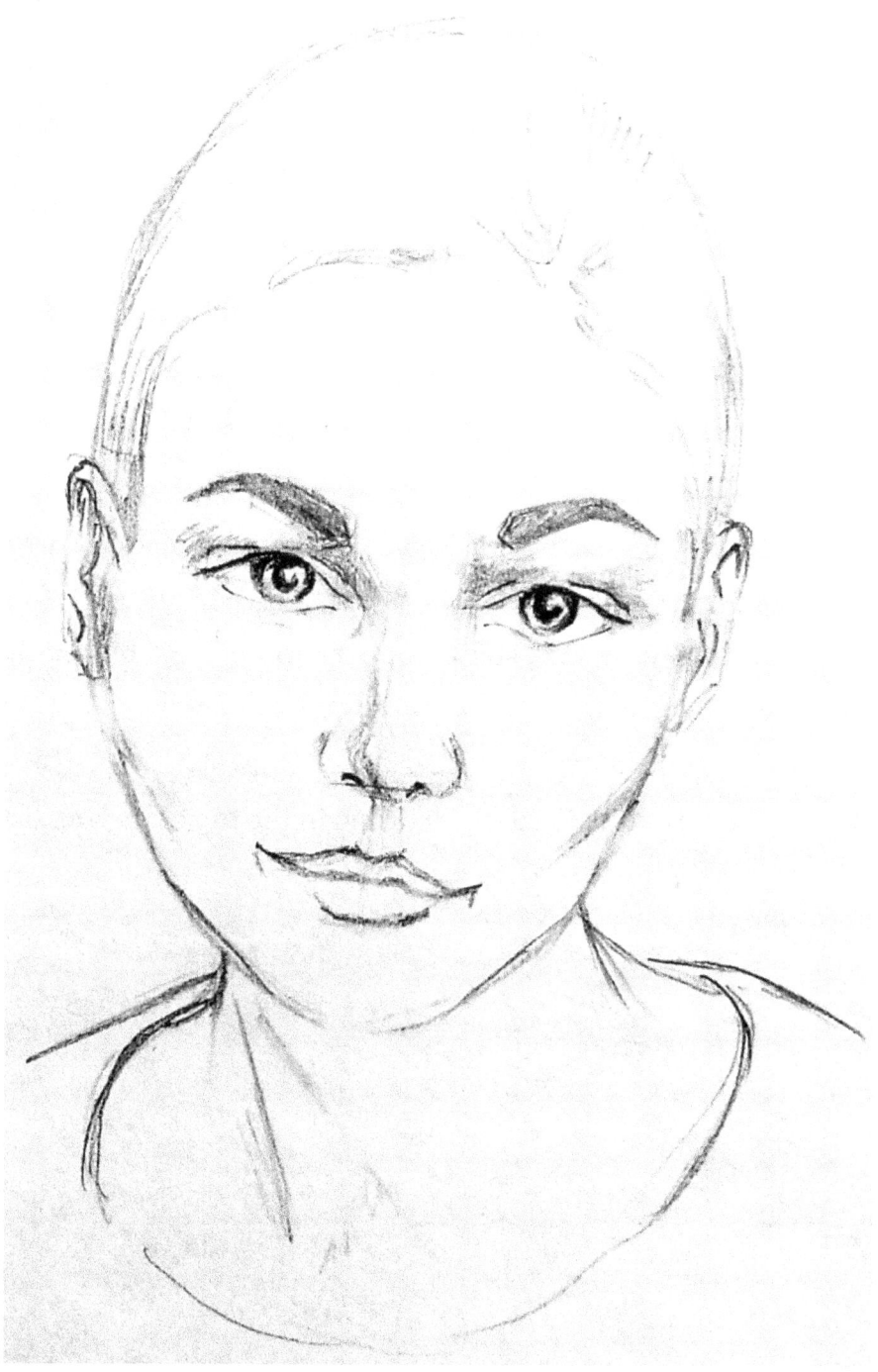

Step #4: Common Issues in the Details

- As you examine this sketch, you'll see that the cheeks have been given more definition to create an angular face. This is all done in the middle section of your sketch.

- Keep in mind; you're working on a tilt, so all the features will be balanced to the tilted vertical line.

- As you begin to work with tilted faces, you'll be tempted to try to make the features even, but doing so will throw your portrait out of balance. The fuller side of your face should appear to be a bit higher than the narrow side.

- The tilt will be carried through the hairline to the top of the head.

Step #5: Shading Details

- Most of your shading is done on the fuller side of the face. This will further define the tilt of the head.

- The same is true with the nose. Shade on the fuller side.

- On this portrait, you'll see that the nose is almost entirely open on the slightly narrow side, with only the nostril showing.

- The detail lines below the nose to the top of the upper lip are also darker on one side than the other.

- On the cheek and neck, draw a few darker strokes moving into the neck and smudge. Your movement in the smudging should follow the same stroking pattern—lightly moving into the center of the neck. This will give weight and value to the tilt.

- Notice the lines that define the neck. On the fuller side, the line is almost to the jaw. On the slightly narrow side, your line is almost two-thirds up the cheek line. This will further illustrate the tilt to the head.

Step #6: Playing with Light & Shadow

- The more shadow you add to the fuller side, the more illusion of the tilt you get in your portrait.

- Notice the shadow that travels down the entire fuller side, from forehead to the bottom of the neck.

- We have also shaded along the fuller side of the nose and above the upper lip on the fuller side so the face has balance and integrity.

- The hair is also more defined on the fuller side, using a softer leaded pencil on one side and your pencil eraser on the other to provide lightness.

- The lower lip is also less defined. Don't hesitate to use your pencil eraser to add light. If you have erased too much shading, simply add more and smudge.

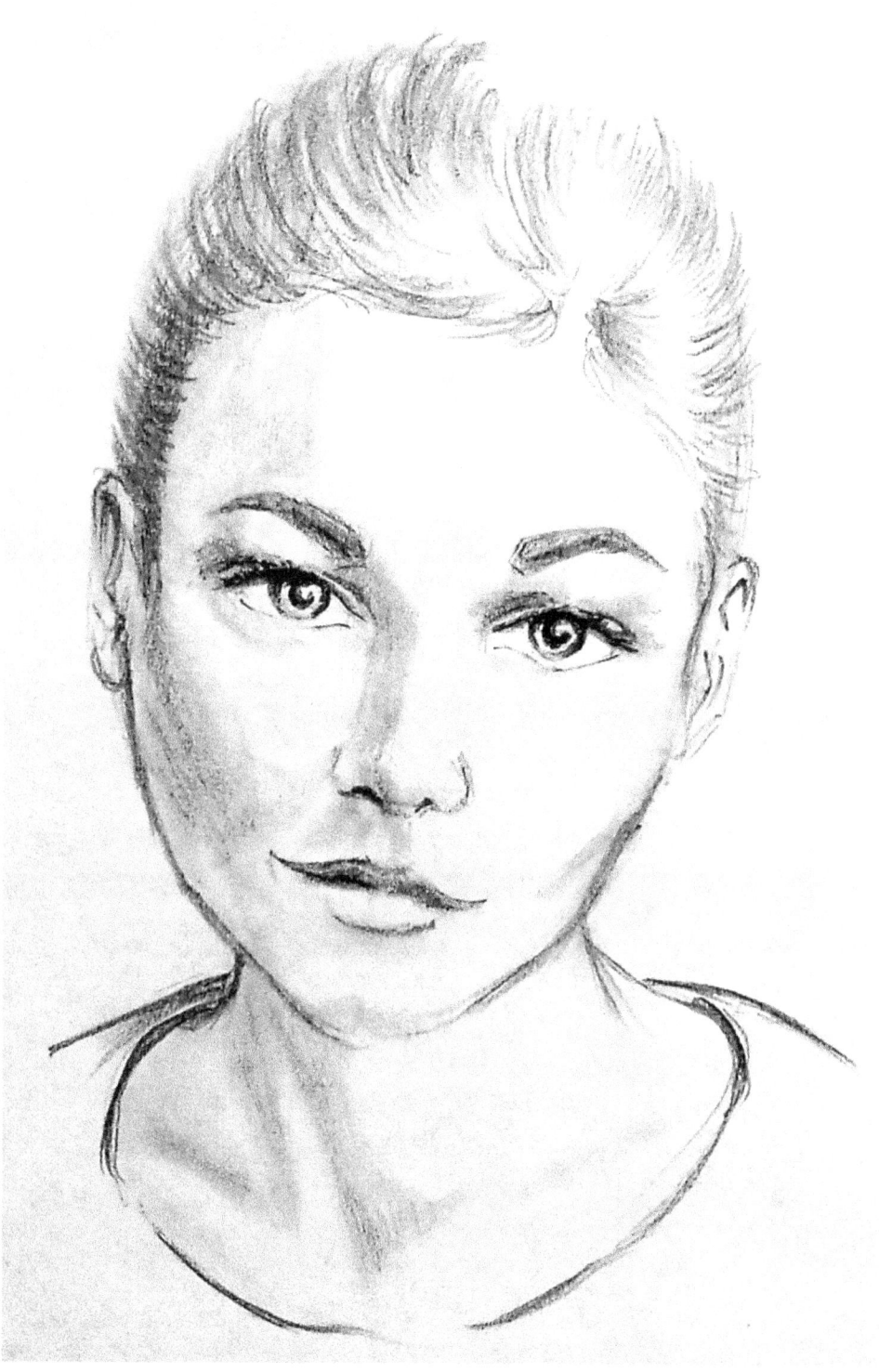

Chapter 10: Creating the Tilt and Downward Face

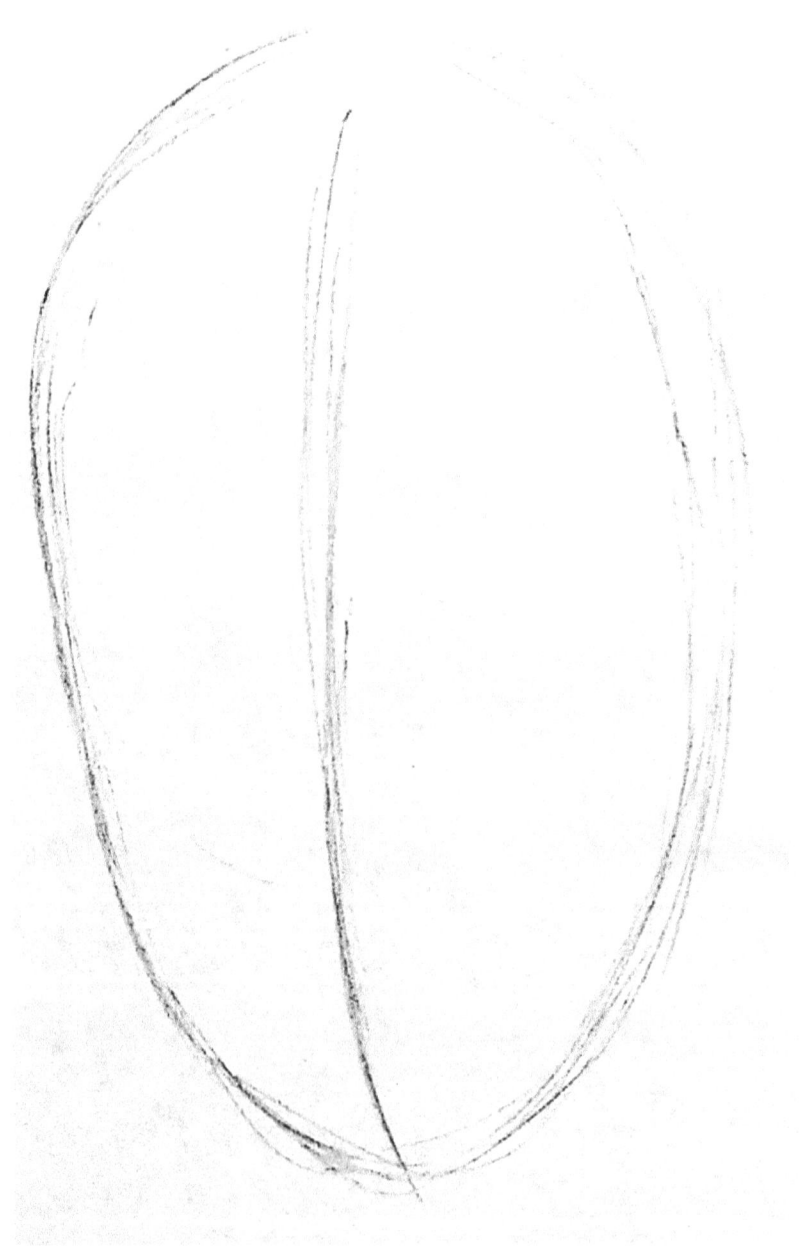

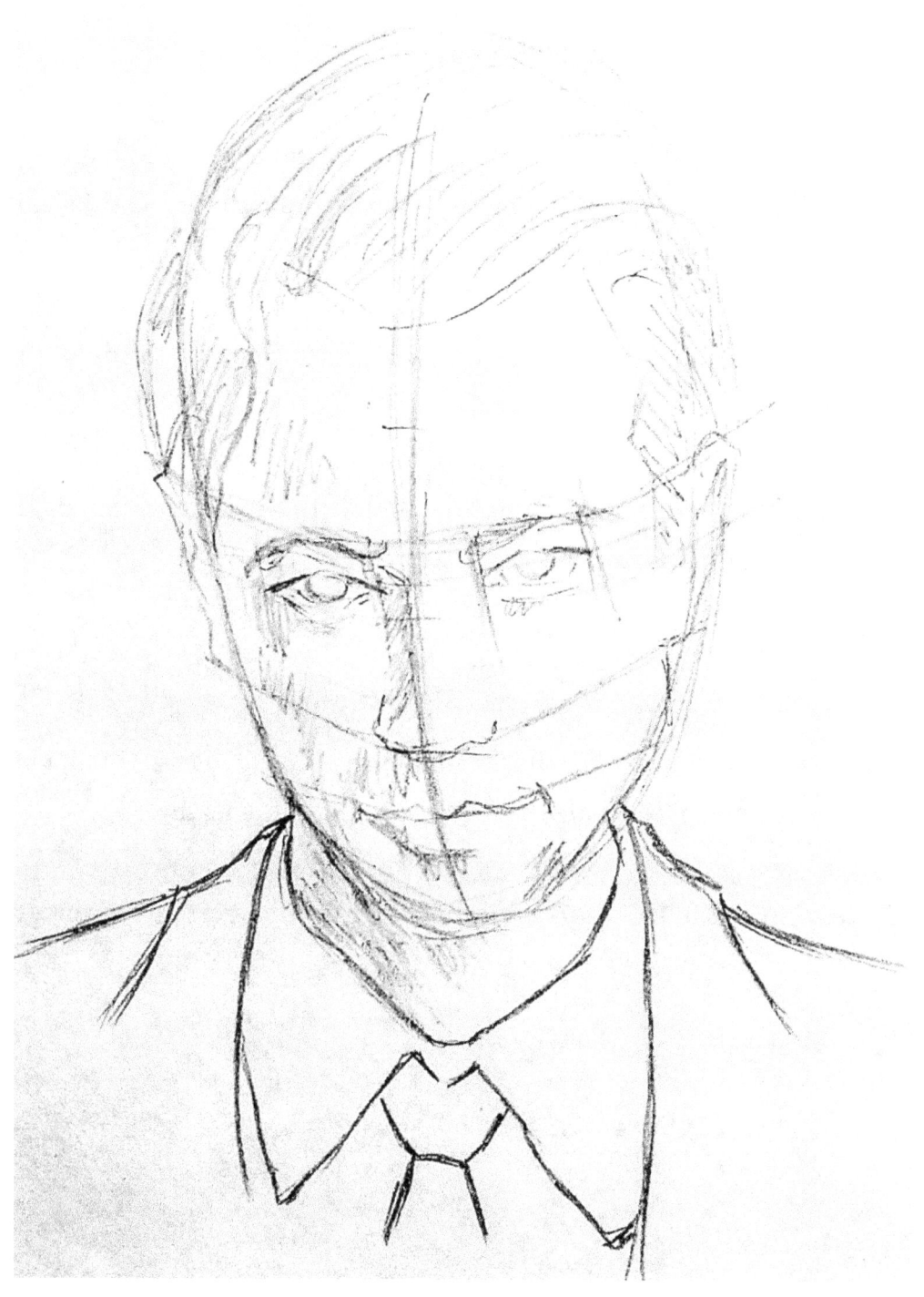

Step #1: Spacing & Feature Placement

- Again, your vertical line should be only slightly off center and have just a bit of a curve. Remember, the more you exaggerate these two things, the more tilt your face will have.

- Looking at the horizontal lines, you will notice that the thirds are not split evenly.

- The top third of the head is larger, the middle third is slight smaller, and the bottom third is significantly smaller.

- This will pull the head in a downward angle.

- Also, pay attention to the horizontal lines; they too are tilted in an upward movement to create the downward tilt to the features.

- The ear on the fuller side should be wider and longer, giving integrity and value to the tilt.

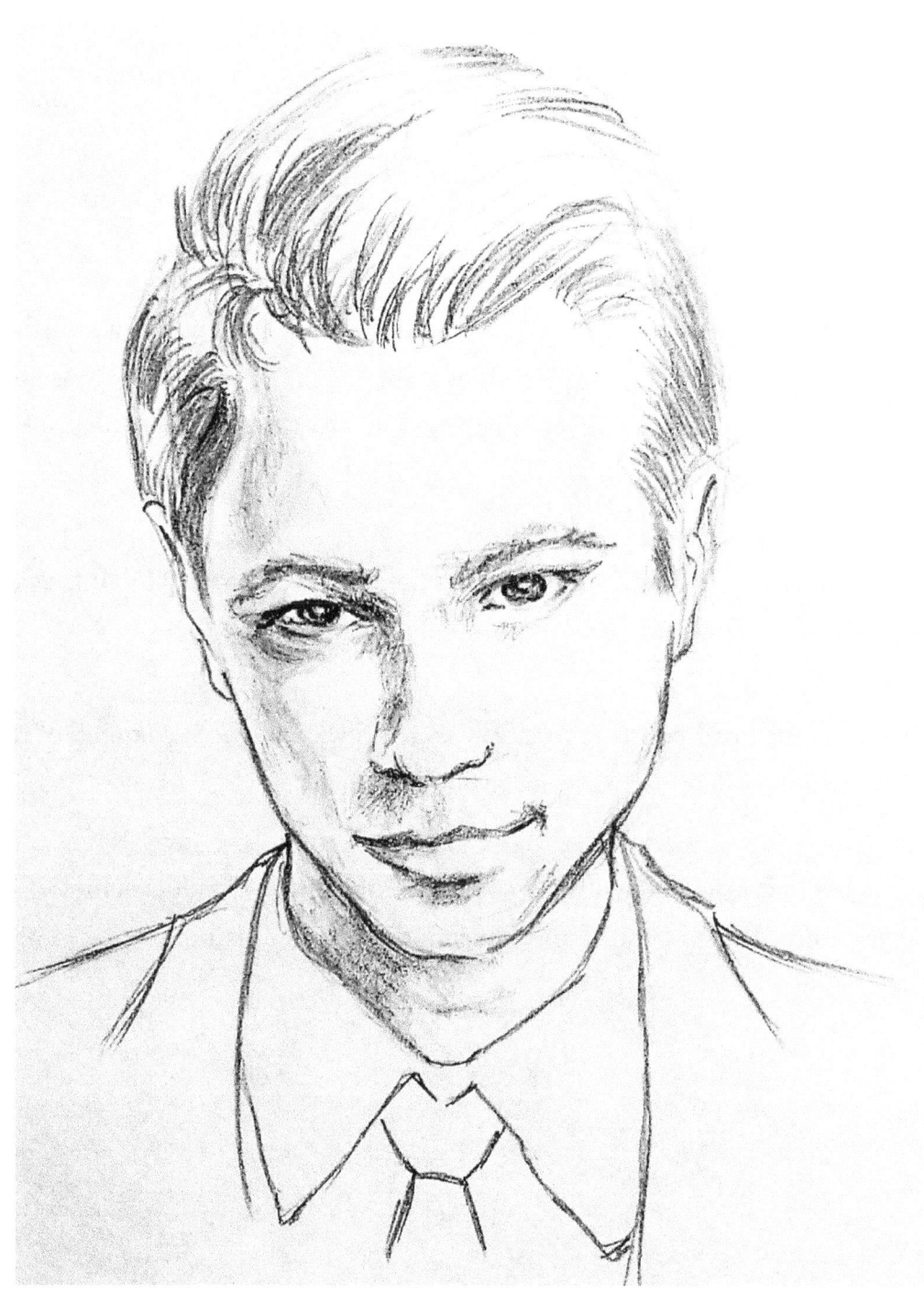

Step #2: Lines & Angles

- The cheeks on this portrait are much more pronounced, so keep your lines heavy and angled.

- Also, the mouth is sketched to look as though the subject has a smirk or half smile. When you want to show expression, exaggerate a line here and there to achieve a different expression. Notice how one side of the lips is elongated and turned up a bit more.

- There is also a slight difference in the details of the ears. The fuller side of the face is showing more of the ear.

- To show the head pointing in a downward tilt, don't draw as much of the neck and leave a little more on the chin.

- This portrait is a good example of the use of weight, which is achieved by using softer leaded pencils and less smudging and erasing.

Step #3: Shading & Light

- To further define the head tilt, the shading is almost all on the narrow side of the face.

- Notice on the subject's nose, the fuller side is just a hint of shading at the corner of the eye, and merely the outline of a nostril.

- There is a lot of shading on one of the eyes as well, which makes the eye set back in the face a bit more.

- As you practice drawing portraits, look closely at faces. Be aware that nobody's faces are perfectly symmetrical. In fact, when they are drawn that way, the portrait tends to look somewhat plastic and unnatural.

- When you want to create expression in the eyes and mouth, play with shading and light until you achieve the look you desire.

- This portrait has just a hint of a neck, which serves to support the downward tilt to the head.

- The finished portrait offers a lot of expression, and with a little practice with angles, weight, placement of your vertical line, shading and light, you can achieve the desired pose.

- By being patient with the final smudging and bringing light into the piece. Bring your subject to life on the page by creating expression.

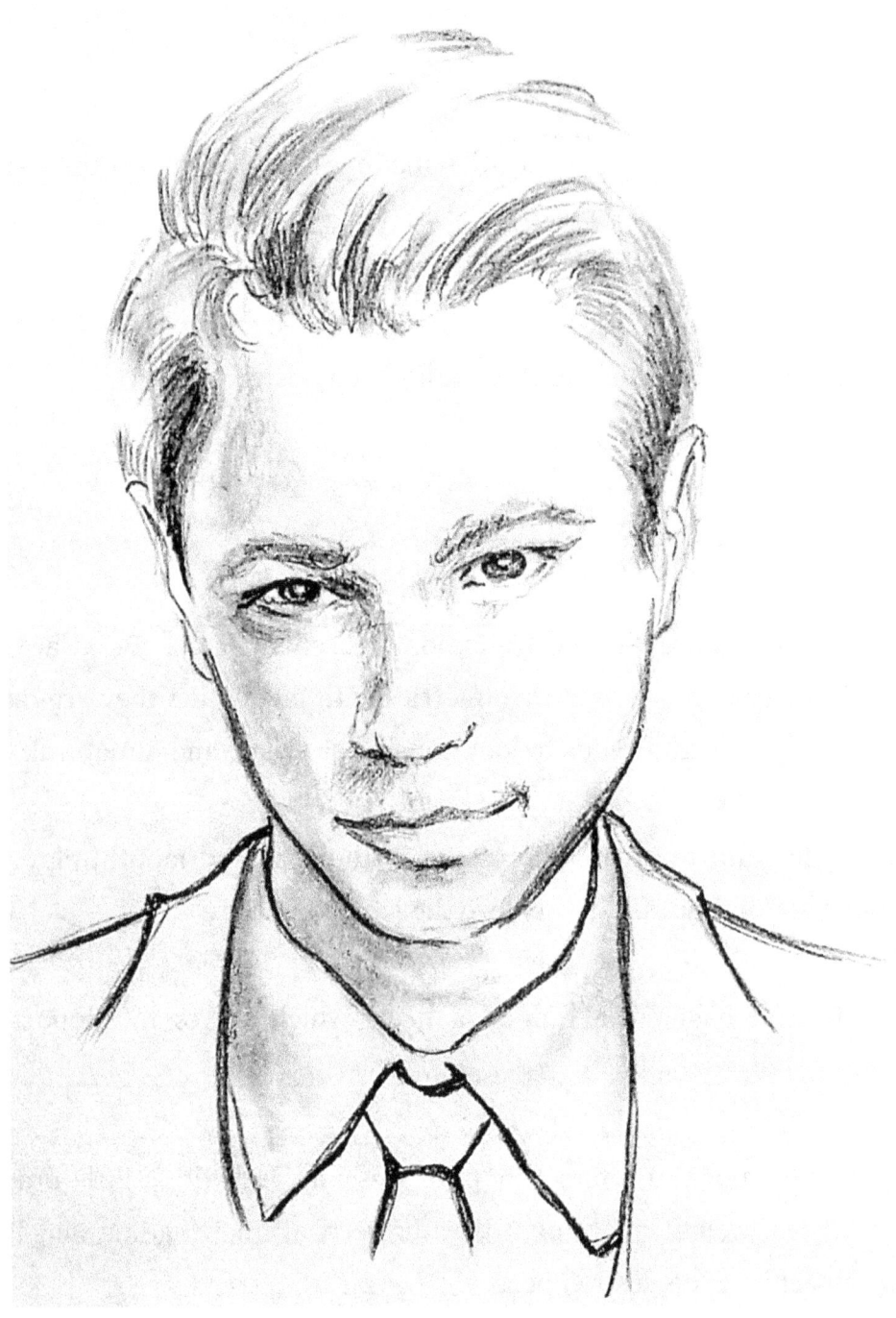

Chapter 11: The Youthful Portrait

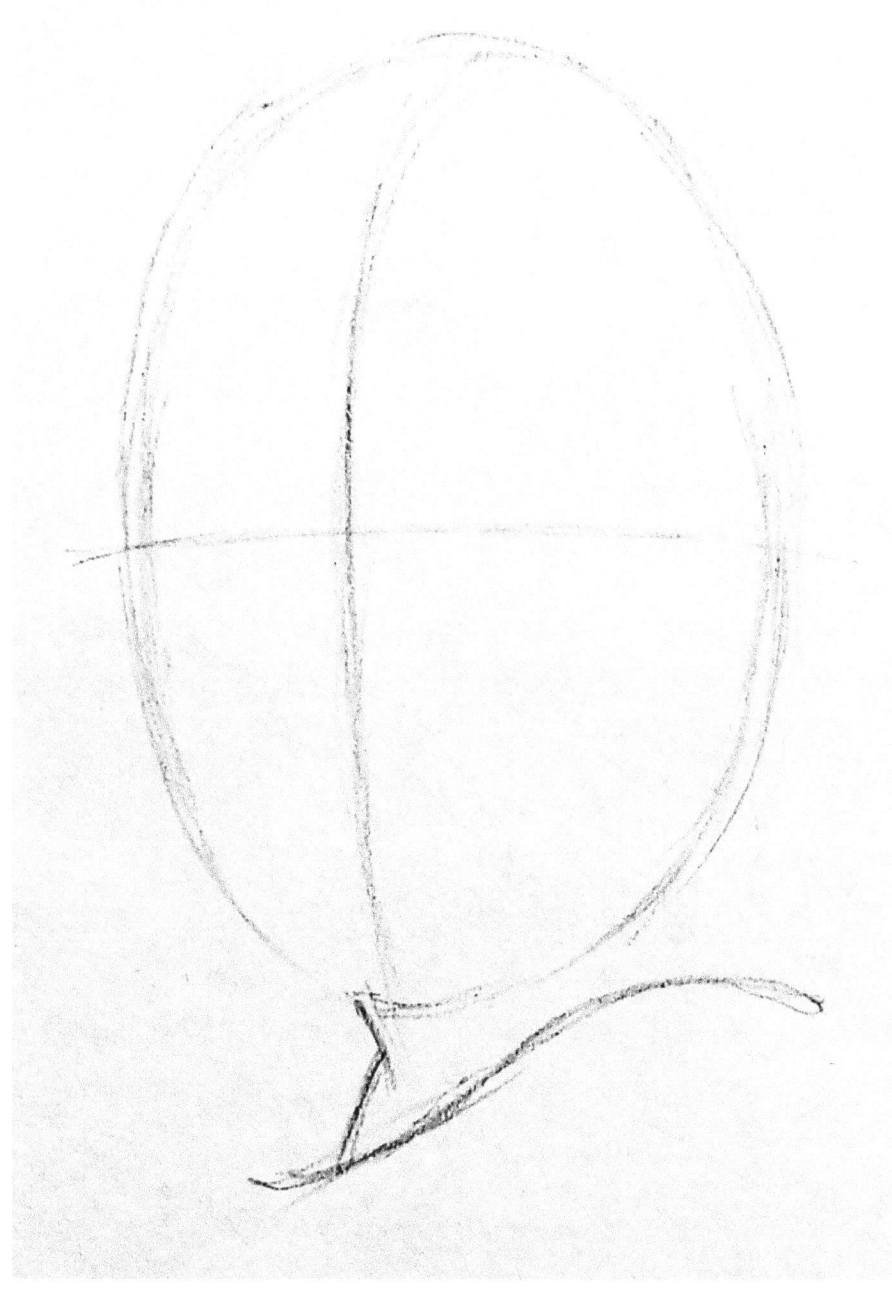

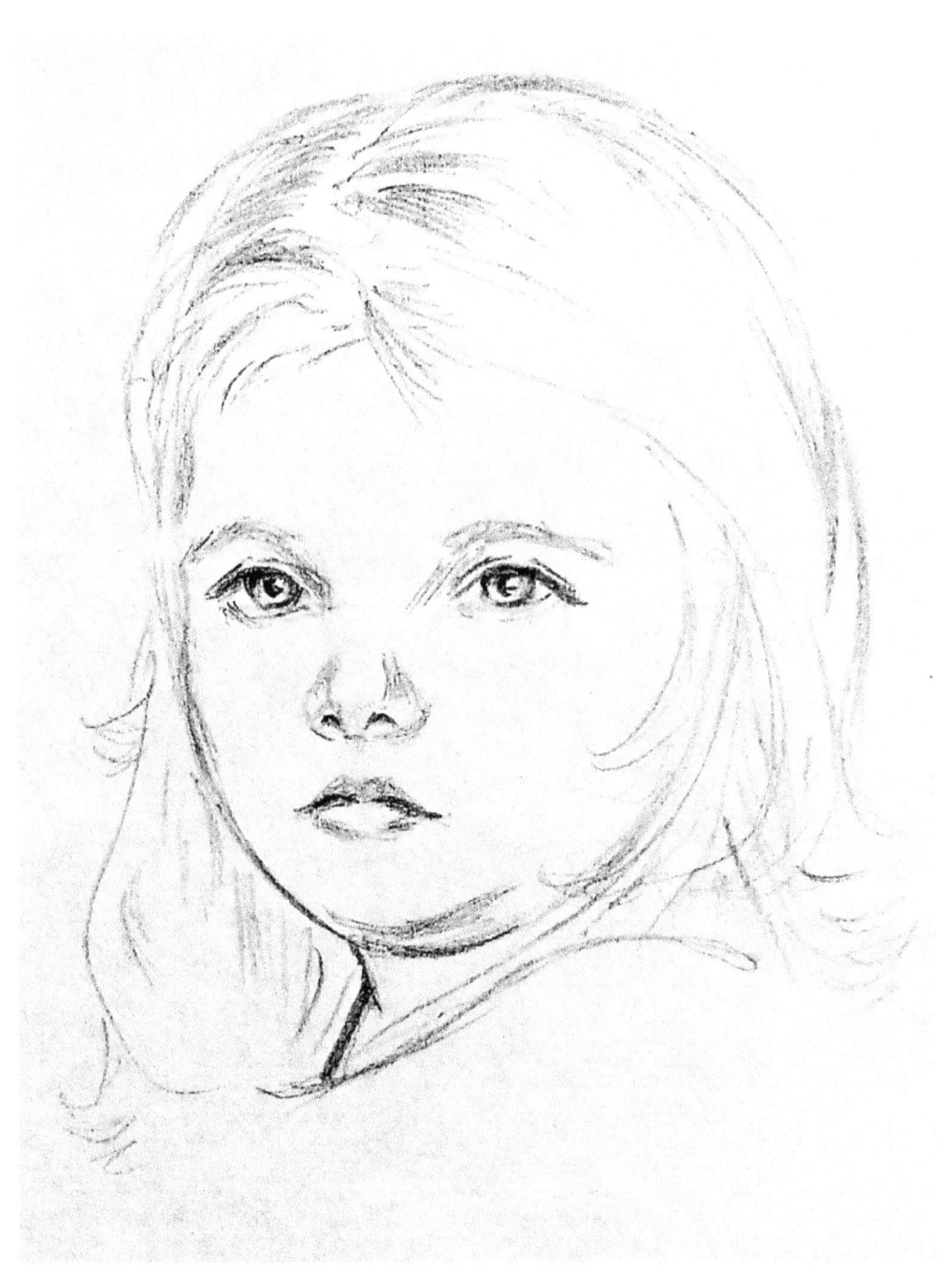

Step #1: Creating a Youthful Portrait

- This one happens to be an over-the-shoulder pose, so follow the directions as you did in Chapter 8.

- You may want to draw your neck and shoulder line as you do your vertical line to balance your features and neckline.

- Notice the cheeks are left relatively full, and the bottom of the head is as round as the top.

- There are almost no angles or shading in this sketch; instead, the portrait is kept light.

Step #2: Youthful Features

- Most all the lines are rounded and plump, with little shading or definition.

- The expression in the eyes and mouth is full and light and the eyes are a bit farther apart to give the portrait a look of innocence.

- The hair is livelier, thicker in appearance. To give it lift, leave yourself more room at the top of the head and use feathered, light strokes with a hard-leaded pencil.

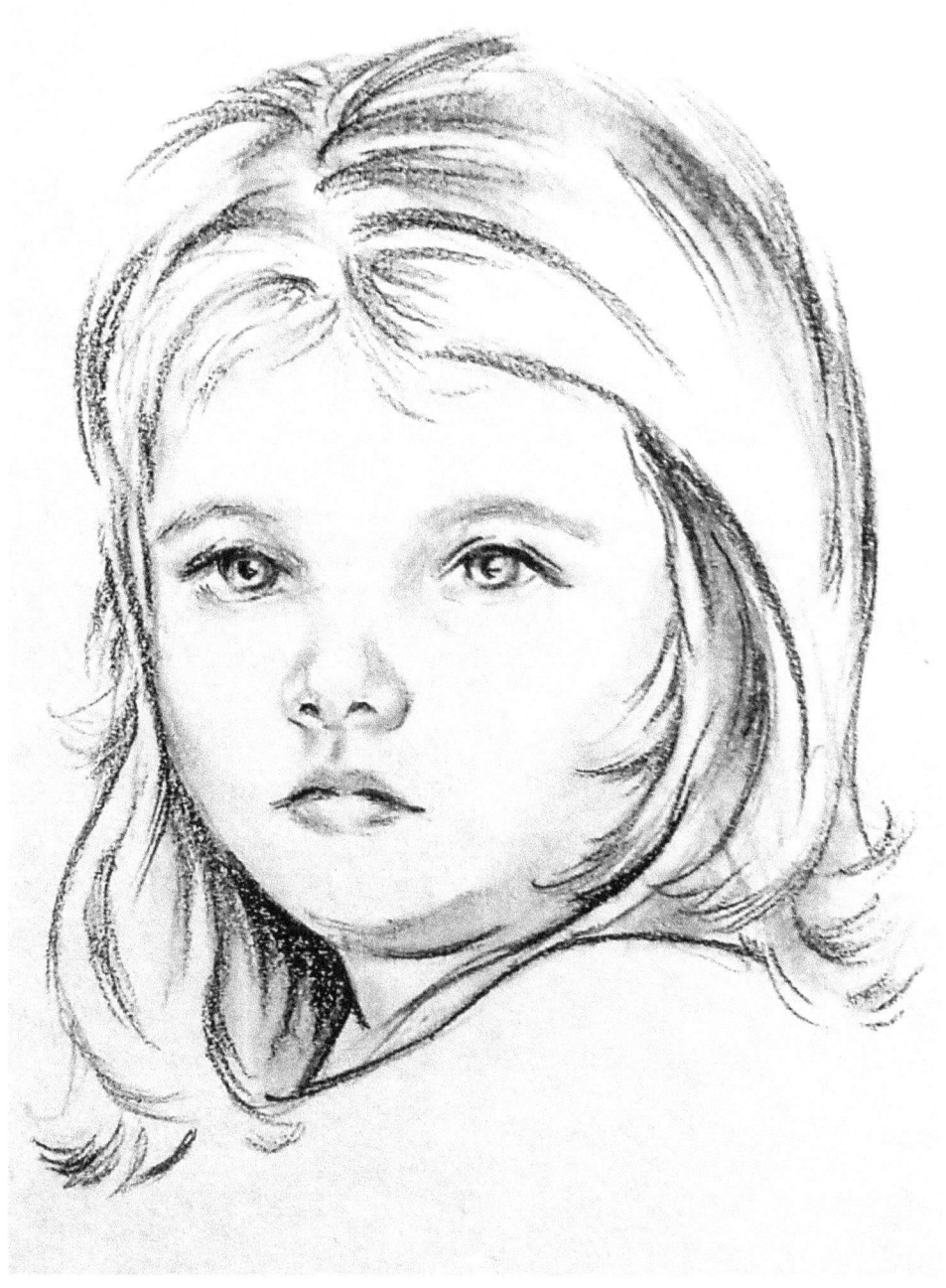

Step #3: Finishing Detail

- Think of everything being softer on a child's portrait.

- Create more light in the eyes by using your pencil eraser.

- Keep the hair tossed and light, with a few darker strokes and lots of smudging.

- The eyes should show almost the entire iris, and it should be a bit oversized for that innocent expression.

- Also, the lids can be thinner, with almost no overhang.

- When sketching a chin, leave it plump and round. This is where you will want to do a little shading, but go light. Too much shading and your portrait will show angles that age her or him.

Chapter 12: You're on Your Own

Now, we're going to give you a finished portrait. Write down the steps, and draw the portrait as you go. Then, check them with the sketches at the end of this chapter to see how you did.

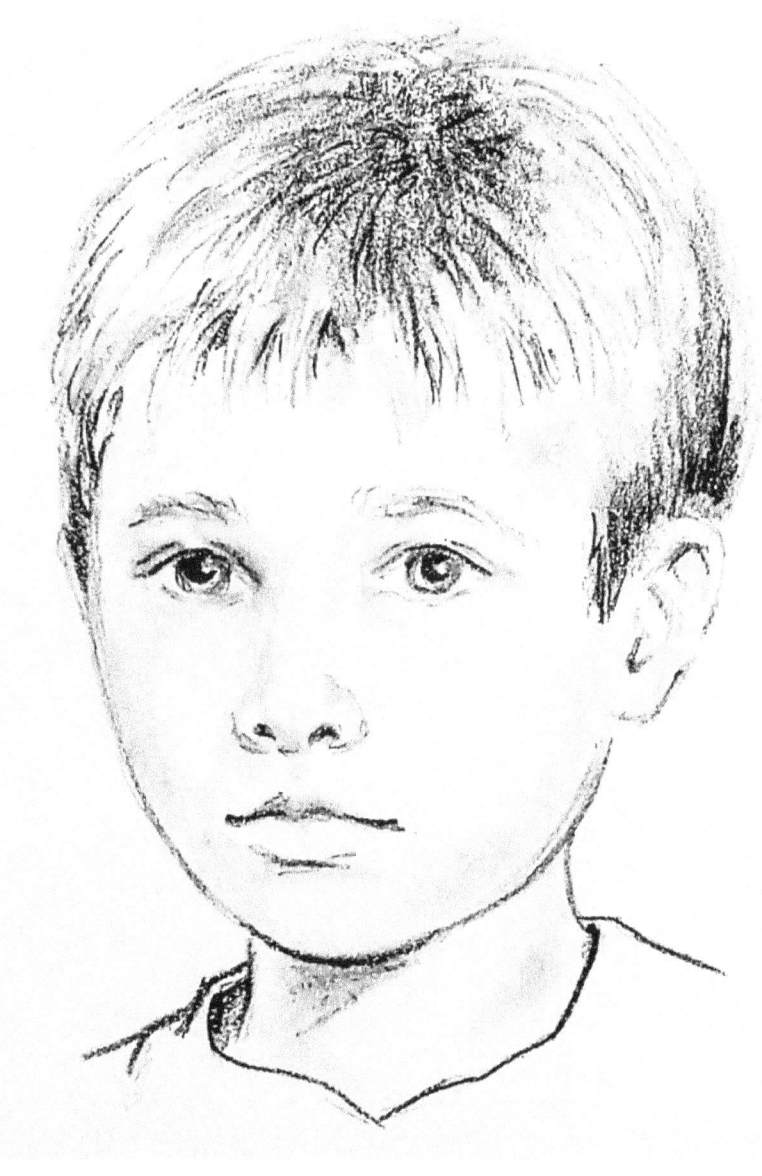

Step #1: Achieving the Head Shape

- _____

- _____

- _____

- _____

- _____

Step #2: Balancing the Features

- _____

- _____

- _____

- _____

- _____

Step #3: Adding the Details

- _____

- _____

- _____

- _____

- _____

Step #4: Using Shading & Light

- _____

- _____

- _____

- _____

- _____

Step #5: The Finished Portrait

-
-
-
-
-

Step #6: Comparing the Sketches

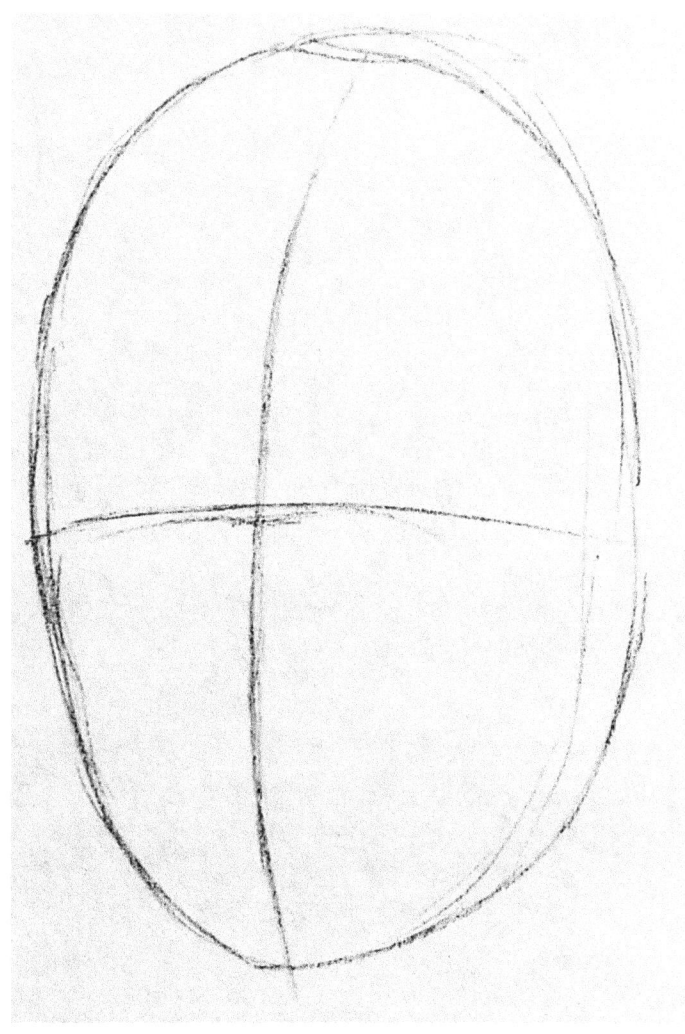

What would you have done differently?

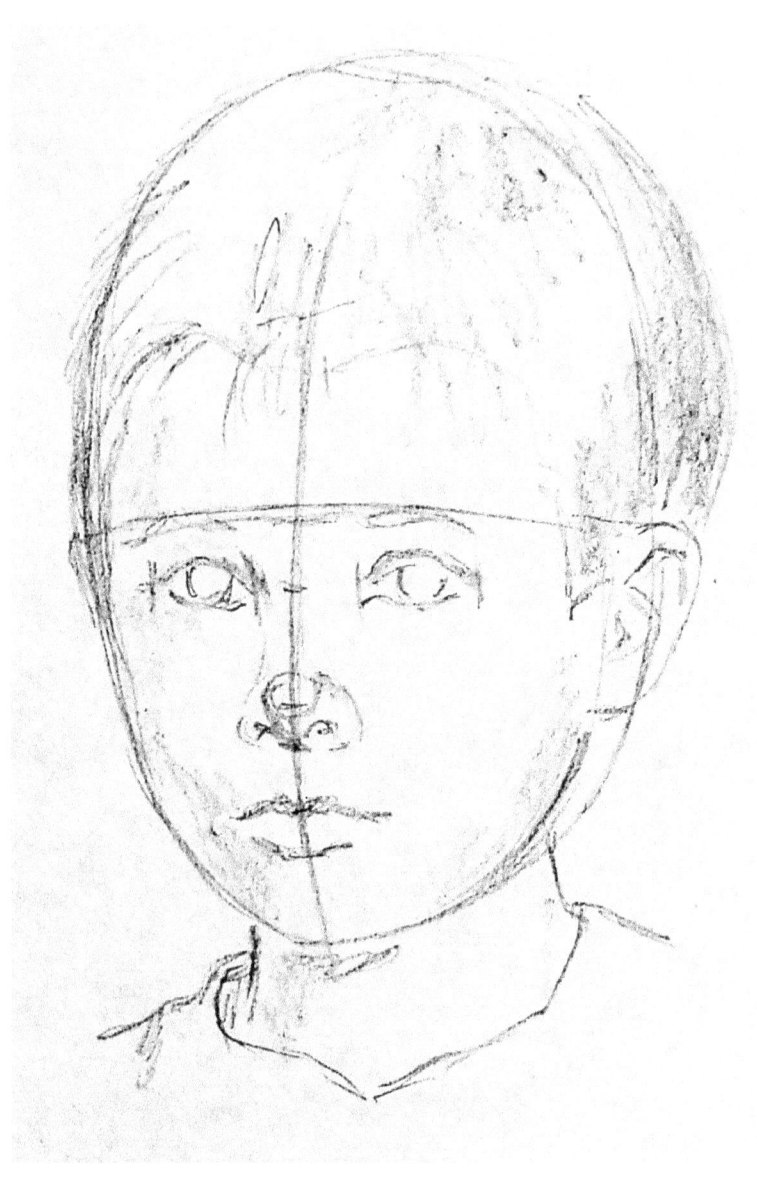

What would you have done differently?

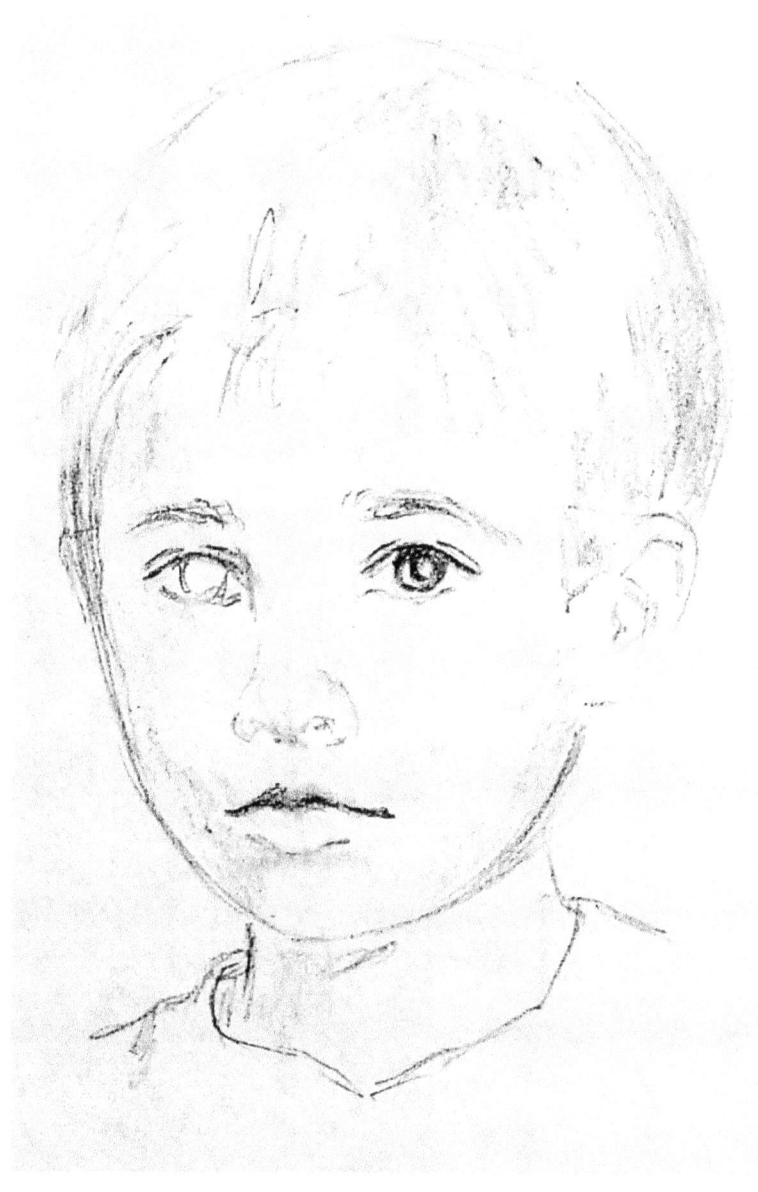

What would you have done differently?

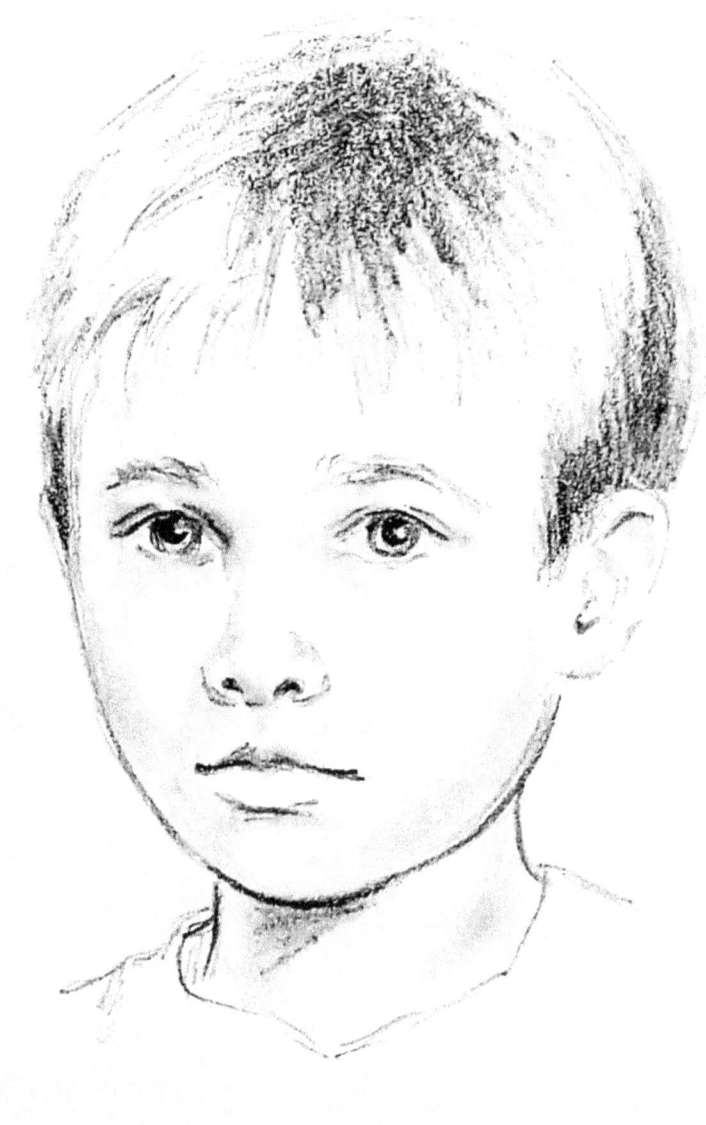

What would you have done differently?

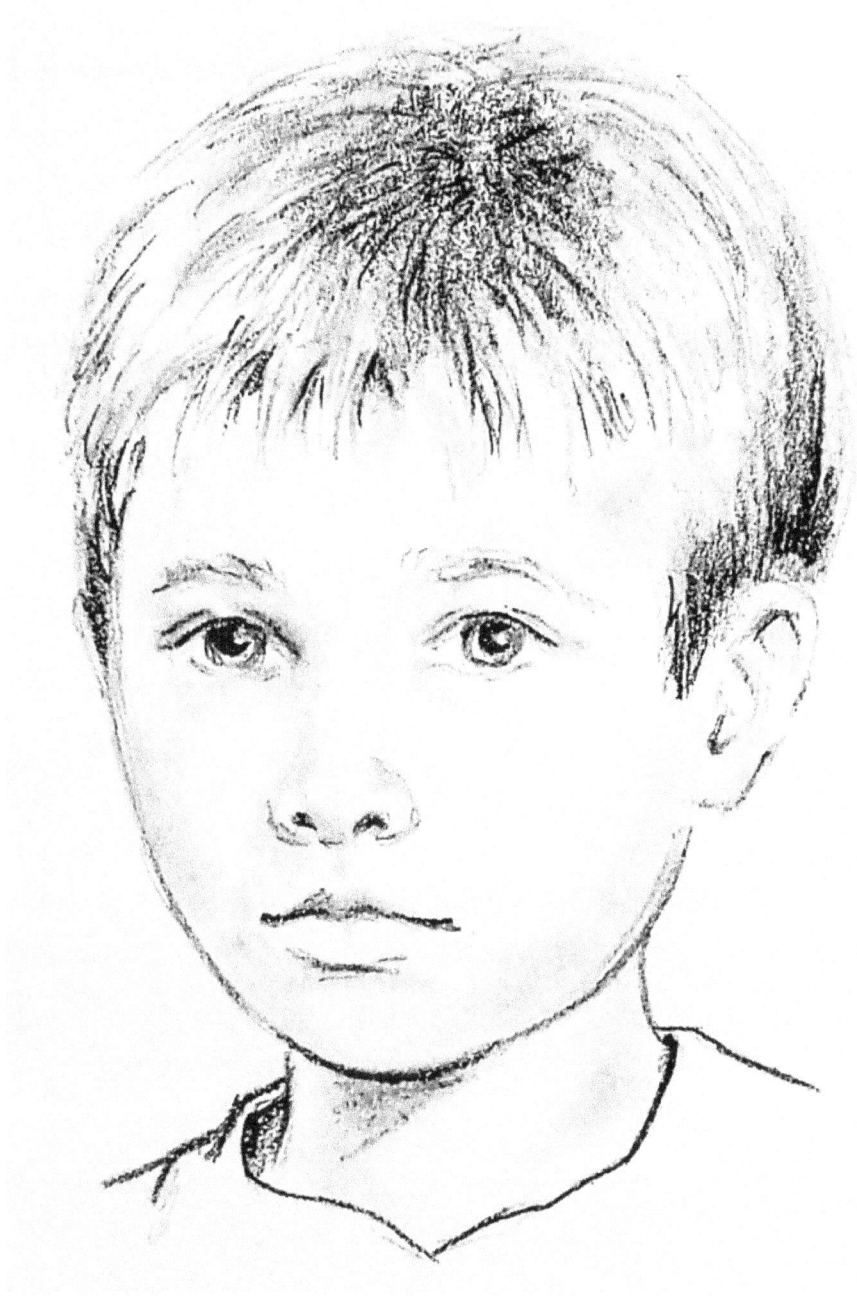

Examine the challenges you had while sketching your portrait. What was out of balance? Why did that happen? Look at the steps you wrote down. What did you miss? Analyze the things you wrote down that you would like to do differently next time.

Being an artist is as much about discipline as it is about creativity. Like any other discipline, it requires diligent practice. To achieve your desired results, you must learn from your mistakes. Without practice and without mistakes, your learning is impeded. The best advice is to be patient with you. Remember, it's not just about the end results, but it's the process that offers great rewards. Enjoy the process. Hone your skills. Celebrate your successes.

Conclusion

Congratulations! You now have the beginnings of a beautifully balanced portrait. Keep practicing and experimenting with different feature shapes, spacing, strokes, and pencils that will add more weight and value to your portraits.

Most importantly, have fun!

Thank you!

Thank you for choosing our book, we hope you found it interesting and helpful.

If you liked the book, please give us a favor to write your review.

We would really appreciate this!

If you would like to have a bonus – **FREE BOOK**, please send the screenshot of your review to this e-mail: **kelly.artbooks@gmail.com** and we will send you a **FREE BOOK** in PDF as a **GIFT!****

Hope to see you in our future books and good luck in your drawing experience!

**** in the e-mail subject please mention the name of the book you reviewed and the author.**